Collins

2024 GUIDE
to the
NIGHT SKY

SOUTHERN HEMISPHERE

Storm Dunlop and Wil Tirion

Published by Collins
An imprint of HarperCollins Publishers
Westerhill Road, Bishopbriggs
Glasgow G64 2QT

HarperCollins Publishers
Macken House,
39/40 Mayor Street Upper,
Dublin 1, D01 C9W8, Ireland
www.harpercollins.co.uk

In association with
Royal Museums Greenwich, the group name for the National Maritime Museum,
Royal Observatory Greenwich, Queen's House and *Cutty Sark* 2015
www.rmg.co.uk

A catalogue record for this book is available from the British Library

ISBN 978-0-00-861961-9

10 9 8 7 6 5 4 3 2 1

Printed in the UAE

If you would like to comment on any aspect of this book, please contact us at the above address or online.

Contents

Introduction

The aim of this Guide is to help people find their way around the night sky, by showing how the stars that are visible change from month to month and by including details of various events that occur throughout the year. The objects and events described may be observed with the naked eye, or nothing more complicated than a pair of binoculars.

The conditions for observing naturally vary over the course of the year. During the summer, twilight may persist throughout the night and make it difficult to see the faintest stars. There are three recognized stages of twilight: civil twilight, when the Sun is less than 6° below the horizon; nautical twilight, when the Sun is between 6° and 12° below the horizon; and astronomical twilight, when the Sun is between 12° and 18° below the horizon. Full darkness occurs only when the Sun is more than 18° below the horizon. During nautical twilight, only the very brightest (navigation) stars are visible. During astronomical twilight, the faintest stars visible to the naked eye may be seen directly overhead, but are lost at lower altitudes. At Sydney, full darkness persists for about six hours at mid-summer. Even at Christchurch, NZ (not shown), full darkness

lasts about four hours. By contrast, as far south as Cape Horn, at mid-summer nautical twilight persists, so only the very brightest stars are visible.

Another factor that affects the visibility of objects is the amount of moonlight in the sky. At Full Moon, it may be very difficult to see some of the fainter stars and objects, and even when the Moon is at a smaller phase it may seriously interfere with visibility if it is near the stars or planets in which you are interested. A full lunar calendar is given for each month and may be used to see when nights are likely to be darkest and best for observation.

The celestial sphere

All the objects in the sky (including the Sun, Moon and stars) appear to lie at some indeterminate distance on a large sphere, centred on the Earth. This *celestial sphere* has various reference points and features that are related to those of the Earth. If the Earth's rotational axis is extended, for example, it points to the North and South Celestial Poles, which are thus in line with the North and South Poles on Earth. Similarly, the *celestial equator* lies in the same plane as the Earth's equator,

The duration of twilight throughout the year at Sydney and Cape Horn.

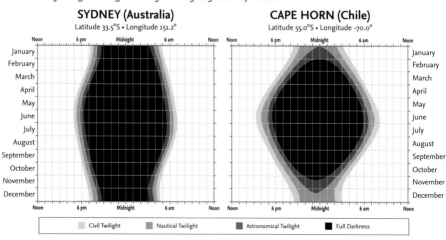

SYDNEY (Australia)
Latitude 33.5°S • Longitude 151.2°

CAPE HORN (Chile)
Latitude 55.0°S • Longitude -70.0°

Civil Twilight Nautical Twilight Astronomical Twilight Full Darkness

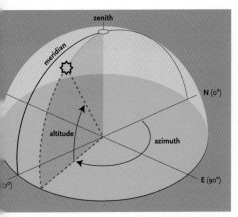

Measuring altitude and azimuth on the celestial sphere.

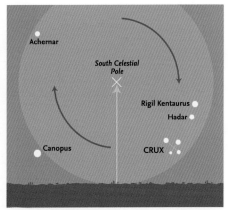

The altitude of the South Celestial Pole equals the observer's latitude.

and divides the sky into northern and southern hemispheres. Because this Guide is written for use in the southern hemisphere, the area of the sky that it describes includes the whole of the southern celestial hemisphere and those portions of the northern that become visible at different times of the year. Stars in the far north, however, remain invisible throughout the year, and are not included.

It is useful to know some of the special terms for various parts of the sky. As seen by an observer, half of the celestial sphere is invisible, below the horizon. The point directly overhead is known as the **zenith**, and the (invisible) one below one's feet as the **nadir**. The line running from the north point on the horizon, up through the zenith and then down to the south point is the **meridian**. This is an important invisible line in the sky, because objects are highest in the sky, and thus easiest to see, when they cross the meridian. Objects are said to **transit**, when they cross this line in the sky.

In this book, reference is frequently made in the text and in the diagrams to the standard compass points around the horizon. The position of any object in the sky may be described by its **altitude** (measured in degrees above the horizon), and its **azimuth** (measured in degrees from north 0°, through east 90°,

south 180° and west 270°). Experienced amateurs and professional astronomers also use another system of specifying locations on the celestial sphere, but that need not concern us here, where the simpler method will suffice.

The celestial sphere appears to rotate about an invisible axis, running between the North and South Celestial Poles. The location (i.e., the altitude) of the Celestial Poles depends entirely on the observer's position on Earth or, more specifically, their latitude. The charts in this book are produced for the latitude of 35°S, so the South Celestial Pole (SCP) is 35° above the southern horizon. The fact that the SCP is fixed relative to the horizon means that all the stars within 35° of the pole are always above the horizon and may, therefore, always be seen at night, regardless of the time of year. The southern circumpolar region is an ideal place to begin learning the sky, and ways to identify the circumpolar stars and constellations will be described shortly.

The ecliptic and the zodiac

Another important line on the celestial sphere is the Sun's apparent path against the background stars – in reality the result of the Earth's orbit around the Sun. This is known as the **ecliptic**. The point where the Sun, apparently moving along the ecliptic,

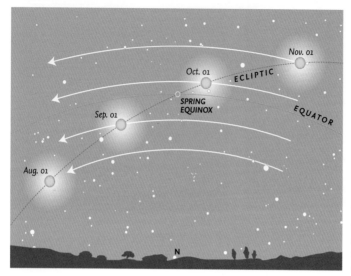

The Sun crossing the celestial equator at the September equinox (spring equinox in the southern hemisphere.).

crosses the celestial equator from south to north is known as the (southern) autumn equinox, which occurs on March 20 or 21. At this time and at the (southern) spring equinox, on September 22 or 23, when the Sun crosses the celestial equator from north to south, day and night are almost exactly equal in length. (There is a slight difference, but that need not concern us here.) The March equinox is currently located in the constellation of Pisces, and is important in astronomy because it defines the zero point for a system of celestial coordinates, which is, however, not used in this Guide.

The Moon and planets are to be found in a band of sky that extends 8° on either side of the ecliptic. This is because the orbits of the Moon and planets are inclined at various angles to the ecliptic (i.e., to the plane of the Earth's orbit). This band of sky is known as the zodiac and, when originally devised, consisted of twelve **constellations**, all of which were considered to be exactly 30° wide. When the constellation boundaries were formally established by the International Astronomical Union in 1930, the exact extent of most constellations was altered and, nowadays, the ecliptic passes through thirteen constellations.

Because of the boundary changes, the Moon and planets may actually pass through several other constellations that are adjacent to the original twelve.

The constellations

Since ancient times, the celestial sphere has been divided into various constellations, most dating back to antiquity and usually associated with certain myths or legendary people and animals. Nowadays, the boundaries of the constellations have been fixed by international agreement and their names (in Latin) are largely derived from Greek or Roman originals. Some of the names of the most prominent stars are of Greek or Roman origin, but many are derived from Arabic names. Many bright stars have no individual names and, for many years, stars were identified by terms such as 'the star in Hercules' right foot'. A more sensible scheme was introduced by the German astronomer Johannes Bayer in the early seventeenth century. Following his scheme – which is still used today – most of the brightest stars are identified by a Greek letter followed by the genitive form of the constellation's Latin name. An example is the Pole Star, also known as Polaris and α

Ursae Minoris (abbreviated α UMi). The Greek alphabet is shown on page 110 and a list of all the constellations that may be seen from latitude 35°S, together with abbreviations, their genitive forms and English names is on page 109. Other naming schemes exist for fainter stars, but are not used in this book.

Asterisms

Apart from the constellations (88 of which cover the whole sky), certain groups of stars, which may form a part of a larger constellation or cross several constellations, are readily recognizable and have been given individual names. These groups are known as *asterisms*, and the most famous (and well-known to northern observers) is the 'Plough', the common name for the seven brightest stars in the constellation of Ursa Major, the Great Bear. The names and details of some asterisms mentioned in this book are given in the list on page 110.

Magnitudes

The brightness of a star, planet or other body is frequently given in magnitudes (mag.). This is a mathematically defined scale where larger numbers indicate a fainter object. The scale extends beyond the zero point to negative numbers for very bright objects. (Sirius, the brightest star in the sky is mag. -1.4.) Most observers are able to see stars to about mag. 6, under very clear skies.

The Moon

Although the daily rotation of the Earth carries the sky from east to west, the Moon gradually moves eastwards by approximately its diameter (about half a degree) in an hour. Normally, in its orbit around the Earth, the Moon passes above or below the direct line between Earth and Sun (at New Moon) or outside the area obscured by the Earth's shadow (at Full Moon). Occasionally, however, the three bodies are more-or-less perfectly aligned to give an *eclipse*: a solar eclipse at New Moon or a lunar eclipse at Full Moon. Depending on the exact circumstances, a solar eclipse may be merely partial (when the Moon does not cover the whole of the Sun's disk); annular (when the Moon is too far from Earth in its orbit to appear large enough to hide the whole of the Sun); or total. Total and annular eclipses are visible from very restricted areas of the Earth, but partial eclipses are normally visible over a wider area.

Somewhat similarly, at a lunar eclipse, the Moon may pass through the outer zone of the Earth's shadow, the *penumbra* (in a penumbral eclipse, which is not generally perceptible to the naked eye), so that just part of the Moon is within the darkest part of the Earth's shadow, the *umbra* (in a partial eclipse); or completely within the umbra (in a total eclipse). Unlike solar eclipses, lunar eclipses are visible from large areas of the Earth.

Occasionally, as it moves across the sky, the Moon passes between the Earth and individual planets or distant stars, giving rise to an *occultation*. As with solar eclipses, such occultations are visible from restricted areas of the world.

The planets

Because the planets are always moving against the background stars, they are treated in some detail in the monthly pages and information is given when they are close to other planets, the Moon or any of five bright stars that lie near the ecliptic. Such events are known as *appulses* or, more frequently, as *conjunctions*. (There are technical differences in the way these terms are defined – and should be used – in astronomy, but these need not concern us here.) The positions of the planets are shown for every month on a special chart of the ecliptic.

The term conjunction is also used when a planet is either directly behind or in front of the Sun, as seen from Earth. (Under normal circumstances it will then be invisible.) The conditions of most favourable visibility depend on whether the planet is one of the two known as *inferior planets* (Mercury and Venus) or one of the three *superior planets* (Mars, Jupiter and Saturn) that are covered in detail. (Some details of the fainter superior planets, Uranus

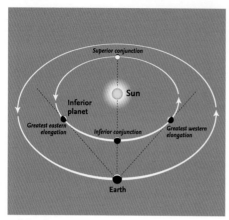

Inferior planet.

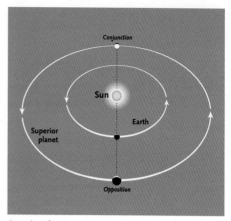

Superior planet.

and Neptune, are included in this Guide, and special charts for both are given on page 25.)

The inferior planets are most readily seen at eastern or western **elongation**, when their angular distance from the Sun is greatest. For superior planets, they are best seen at **opposition**, when they are directly opposite the Sun in the sky, and cross the meridian at local midnight.

It is often useful to be able to estimate angles on the sky, and approximate values may be obtained by holding one hand at arm's length. The various angles are shown in the diagram, together with the separations of the various stars in and around Orion.

Meteors

At some time or other, nearly everyone has seen a **meteor** – a 'shooting star' – as it flashed across the sky. The particles that cause meteors – known technically as 'meteoroids' – range in size from that of a grain of sand (or even smaller) to the size of a pea. On any night of the year there are occasional meteors, known as **sporadics**, that may travel in any direction. These occur at a rate that is normally between three and eight in an hour. Far more important, however, are **meteor showers**, which occur at fixed periods of the year, when the Earth encounters a trail of particles left behind by a comet or, very occasionally, by a minor

planet (asteroid). Meteors always appear to diverge from a single point on the sky, known as the **radiant**, and the radiants of major showers are shown on the charts. Meteors that come from a circular area 8° in diameter around the radiant are classed as belonging to the particular shower. All others that do not come from that area are sporadics (or, occasionally from another shower that is active at the same time). A list of the major meteor showers is given on page 31.

Although the positions of the various shower radiants are shown on the charts, looking directly at the radiant is not the most effective way of seeing meteors. They are most likely to be noticed if one is looking about 40–45° away from the radiant position. (This is approximately two hand-spans as shown in the diagram for measuring angles.)

Other objects

Certain other objects may be seen with the naked eye under good conditions. Some were given names in antiquity – Praesepe is one example – but many are known by what are called 'Messier numbers', the numbers in a catalogue of nebulous objects compiled by Charles Messier in the late eighteenth century. Some, such as the Andromeda Galaxy, M31, and the Orion Nebula, M42, may be seen by the naked eye, but all those given in the list will benefit from the use of binoculars.

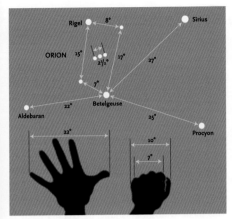

Measuring angles in the sky.

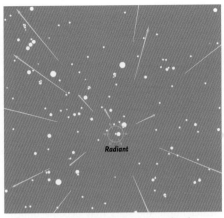

Meteor shower (showing the Geminids radiant).

Apart from galaxies, such as M31, which contain thousands of millions of stars, there are also two types of cluster: open clusters, such as M45, the Pleiades, which may consist of a few dozen to some hundreds of stars; and globular clusters, such as Omega Centauri, which are spherical concentrations of many thousands of stars. One or two gaseous nebulae (emission nebulae), consisting of gas illuminated by stars within them, are also visible. The Orion Nebula, M42, is one, and is illuminated by the group of four stars, known as the Trapezium, which may be seen within it by using a good pair of binoculars.

Some interesting objects.

Messier / NGC	Name	Type	Constellation	Maps (months)
—	47 Tucanae	globular cluster	Tucana	All year
—	Hyades	open cluster	Taurus	Oct. – Feb.
—	Melotte 111 (Coma Cluster)	open cluster	Coma Berenices	Mar. – Jun.
M3	—	globular cluster	Canes Venatici	Mar. – Jul.
M4	—	globular cluster	Scorpius	Mar. – Sep.
M8	Lagoon Nebula	gaseous nebula	Sagittarius	Apr. – Oct.
M11	Wild Duck Cluster	open cluster	Scutum	May – Oct.
M13	Hercules Cluster	globular cluster	Hercules	May – Aug.
M15	—	globular cluster	Pegasus	Jul. – Nov.
M20	Trifid Nebula	gaseous nebula	Sagittarius	Apr. – Oct.
M22	—	globular cluster	Sagittarius	Apr. – Oct.
M27	Dumbbell Nebula	planetary nebula	Vulpecula	Jun. – Oct.
M31	Andromeda Galaxy	galaxy	Andromeda	Sep. – Dec.
M35	—	open cluster	Gemini	Nov. – Mar.
M42	Orion Nebula	gaseous nebula	Orion	Oct. – Apr.
M44	Praesepe	open cluster	Cancer	Dec. – Apr.
M45	Pleiades	open cluster	Taurus	Oct. – Feb.
M57	Ring Nebula	planetary nebula	Lyra	Jun. – Sep.
M67	—	open cluster	Cancer	Dec. – May
IC 2602	Southern Pleiades	open cluster	Carina	All year
NGC 2070	Tarantula Nebula	emission nebula	Dorado (LMC)	All year
NGC 3242	Ghost of Jupiter	planetary nebula	Hydra	Jan. – Jun.
NGC 3372	Eta Carinae Nebula	gaseous nebula	Carina	All year
NGC 4755	Jewel Box	open cluster	Crux	All year
NGC 5139	Omega Centauri	globular cluster	Centaurus	Jan. – Sep.

The Southern Circumpolar Constellations

The southern circumpolar constellations are the key to to starting to identify the constellations. For anyone in the southern hemisphere, they are visible at any time of the year, and nearly everyone is familiar with the striking pattern of four stars that make up the constelllation of **Crux** (the Southern Cross), and also the two nearby bright stars **Rigil Kentaurus** and **Hadar** (α and β Centauri, respectively). This pattern of stars is visible throughout the year for most observers, although for observers farther north, the stars may become difficult to see, low on the horizon in the southern spring, espcially in the months of October and November.

A line through **Gacrux** (γ Crucis) and **Acrux** (α Crucis) points approximately in the direction of the South Celestial Pole, crossing the faint constellations of **Musca** and **Chamaeleon**. Although there is no bright star close to the South Celestial Pole (and even the constellation in which it lies, **Octans**, is faint), an idea of its location helps to identify the region of sky that is always visible. (The altitude of the South Celestial Pole is equal to the observer's latitude south of the equator.) The basic triangular shape of Octans itself is best found by extending a line from **Peacock** (α Pavonis) through β Pavonis, by about the same distance as that between the stars.

Crux

The distinctive shape of the constellation of **Crux** is usually easy to identify, although some people (especially northerners unused to the southern sky) may wrongly identify the slightly larger False Cross, formed by the stars **Aspidiske** and **Avior** (ι and ϵ Carinae respectively) plus **Markeb** and **Alsephina** (κ and δ Velorum). The dark patch of the Coalsack (a dark cloud of obscuring dust) is readily visible on the eastern side of Crux between **Acrux** and **Mimosa** (α and β Crucis).

Centaurus

Although Crux is a distinctive shape, **Centaurus** is a large, rather straggling constellation, with one notable object, the giant, bright globular cluster **Omega Centauri** (the brightest globular in the sky), which lies towards the north, on the line from **Hadar** (β Centauri) through ϵ Centauri. Rather than locating the South Celestial Pole from Crux, a better indication is the line, at right angles to the line between Hadar and Rigil Kentaurus that passes across the brightest star in **Circinus** (α).

Carina

Apart from the two stars that form part of the False Cross, the constellation of Carina is, like Centaurus, a large, sprawling constellation. It contains one striking open cluster, the **Southern Pleiades**, and a remarkable emission nebula, the **Eta Carinae Nebula**. The second brightest star in the sky (after Sirius) is **Canopus**, α Carinae, which lies far away to the west.

The Magellanic Clouds

On the opposite side of the South Celestial Pole to Crux and Centaurus lie the two Magellanic Clouds. The **Small Magellanic Cloud** (SMC) lies to one side of the relatively inconspicuous, triangular constellation of **Hydrus**, but is actually within the constellation of **Tucana**.

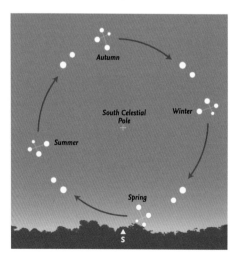

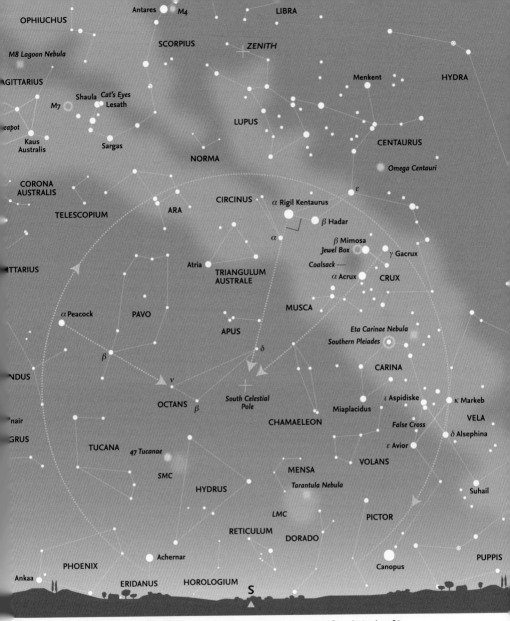

The stars and constellations inside the circle are always above the horizon, seen from latitude 35°S.

Nearby is another bright globular cluster, **47 Tucanae**. Hydrus itself is also easily identified from the star, **Achernar**, α Eridani, the rather isolated brilliant star at the southern end of **Eridanus**, which wanders a long way south, having begun at the foot of Orion.

The **Large Magellanic Cloud** (LMC) lies within the faint constellation of **Dorado**. Not only is it a large satellite galaxy of the Milky Way Galaxy, but it contains the large, readily visible, **Tarantula Nebula**, an emission nebula that is a major star-forming region.

THE CONSTELLATIONS **11**

The Summer Constellations

The summer sky is dominated by the constellation of **Orion**, with its three 'Belt' stars, as well as by the three bright stars: **Betelgeuse** (α Orionis), **Sirius** (α Canis Majoris), and **Procyon** (α Canis Minoris), which together form the prominent (Southern) 'Summer Triangle'. To the west of Orion is **Taurus**, with orange **Aldebaran** (α Tauri). A line from **Bellatrix** (γ Orionis) through Aldebaran points to the striking **Pleiades** cluster (M45). (The line of three 'Belt' stars indicates the same general path and, in the other direction, points towards Sirius.) A line from **Mintaka** (the westernmost star of the 'Belt') through brilliant **Rigel** (β Orionis) points in the direction of **Achernar** (α Eridani). One from **Alnitak** (at the other end of the 'Belt') through **Saiph** (κ Orionis) indicates the direction of **Canopus** (α Carinae), the second brightest star in the whole sky. A line from Betelgeuse through Sirius points in the general direction of the 'False Cross' in **Vela** and **Carina**.

In the opposite (northern) side of Orion, a line from **Meissa** (λ Orionis) through **Elnath** (β Tauri) leads to **Capella** (α Aurigae), and one from **Betelgeuse** through **Alhena** (γ Geminorum) points to **Pollux** (β Geminorium), the southernmost of the distinctive Castor/Pollux pair. A line across Orion from Bellatrix to Betelgeuse, if extended greatly, indicates the general direction of **Regulus** (α Leonis).

Six of the bright stars that have been mentioned, in different constellations: Capella, Aldebaran, Rigel, Sirius, Procyon and Pollux form what, for northern observers, is sometimes known as the 'Winter Hexagon'. Pollux is accompanied to the northwest by the slightly fainter star of **Castor** (α Geminorum), the second 'Twin'.

Several of the stars in this region of the sky show distinctive tints: Betelgeuse (α Orionis) is reddish, Aldebaran (α Tauri) is orange and Rigel (β Orionis) is blue-white.

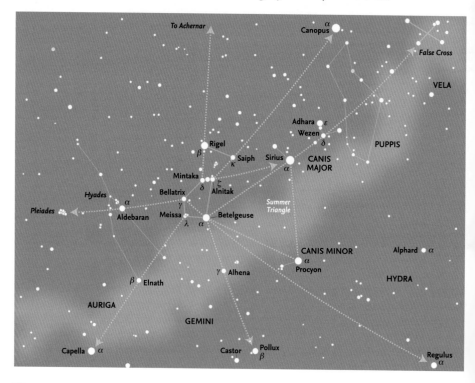

The Autumn Constellations

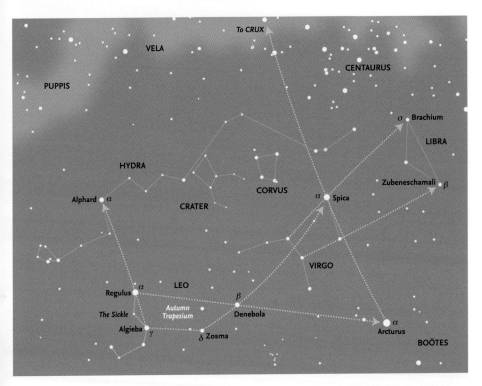

During the autumn season, the principal constellation is the zodiacal constellation of **Leo**, whose principal star **Regulus** (α Leonis) is one of the five bright stars that may occasionally be occulted by the Moon. Regulus forms the 'dot' of the upside-down 'question mark' of stars, known as the 'Sickle'. The body of Leo itself is sometimes known as the 'Trapezium' (here, the 'Autumn Trapezium'), and its sides may be used to find other objects in the sky.

A line extended from **Algiebra** (γ Leonis), the second star in the 'Sickle', through Regulus points to **Alphard** (α Hydrae) the brightest star in **Hydra**, the largest of the 88 constellations, which sprawls a long way across the sky from its distinctively shaped 'head' of stars, southwest of Regulus. A line from Regulus through **Denebola** (β Leonis) at the other end of the constellation of Leo points towards **Arcturus** (α Boötis), the brightest star in the

northern hemisphere of the sky. Another line, down the 'back' of Leo, from **Zosma** (δ Leonis) through Denebola points in the general direction of **Spica** (α Virginis) the principal star in the constellation of **Virgo**.

Although Spica is the brightest star in the zodiacal constellation of Virgo, the remainder of the constellation is not remarkable, consisting of a rough quadrilateral of stars with fainter lines extending outwards. The two sides of the main quadrilateral, if extended, point eastwards towards the two principal stars, **Zubeneschamali** and **Brachium** (β and σ Librae, respectively), of the small zodiacal constellation of **Libra**. The two small constellations of **Corvus** and **Crater** lie between Virgo and the long stretch of Hydra. A line from Arcturus through Spica, if extended far to the south across the sky, points to the distinctive constellation of **Crux**.

The Winter Constellations

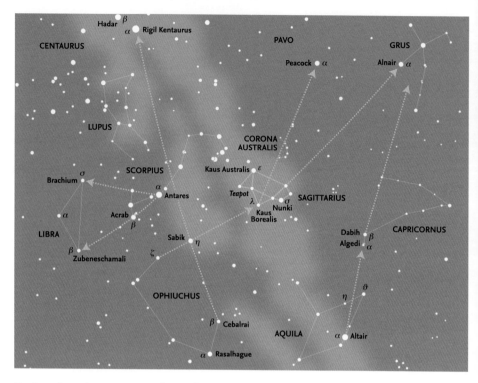

During the winter season, the Milky Way runs right across the sky, and the distinctive constellation of *Scorpius* is clearly visible, with bright red **Antares** (α Scorpii) and the 'sting', trailing behind the star to the west. Scorpius used to be a much larger constellation until the small zodiacal constellation of **Libra** was formed from some of its stars. The two sides of the 'fan' of stars immediately east of Antares, if extended, point to the two principal stars of Libra, **Zubeneschamali** and **Brachium** (β and σ Librae, respectively) on the southern and northern sides of the constellation.

North of Scorpius lies the large constellation of **Ophiuchus**. The ecliptic runs through the southern portion of Ophiuchus, and the Sun spends far more time in that constellation than it does in neighbouring Scorpius. A line from **Cebalrai** (β Ophiuchi) in the north of the constellation, through **Sabik** (η Ophiuchi), if extended right across Scorpius, carries you to the two bright stars of **Centaurus, Rigil Kentaurus** and **Hadar** (α and β Centauri, respectively). Between Libra and Centaurus lies the straggling constellation of **Lupus** with no distinct pattern of stars.

A line from the fainter star ζ Ophiuchi through **Sabik** points towards **Kaus Borealis** (λ Sagittarii) the 'lid' of the 'Teapot' of **Sagittarius**. From there two lines radiate (on the west) across **Corona Australis** towards **Peacock** (α Pavonis) and (on the east) **Alnair** (α Gruis) in the small constellation of **Grus**.

Also north of **Scorpius** is the constellation of **Aquila**, with its brightest star, **Altair** (α Aquilae). The diamond shape of the 'wings' of Aquila may be used to locate **Algedi** (α Capricorni), a prominent double star in **Capricornus**. A line through **Dabih** (β Capricorni) and the western side of that basically triangular constellation, when extended, also points in the direction of the constellation of **Grus**.

The Spring Constellations

In spring, the constellation of **Pegasus** and the Great Square of Pegasus are prominent in the north. One star in the Square, **Alpheratz**, at the northwestern corner, actually belongs to the neighbouring constellation of **Andromeda**. A diagonal line across the Square from Alpheratz (α Andromedae) through **Markab** (α Pegasi) points to **Sadalmelik** (α Aquarii), just to the west of the 'Y-shaped' asterism of the 'Water Jar' in the zodiacal constellation of **Aquarius**. Further extended, that line carries you to the centre of the triangular constellation of **Capricornus**.

The constellation of **Pisces** consists of two lines of stars running to the south and east of the Great Square. In mythological representations, the two fish are linked by ribbons, tied together at **Alrescha** (α Piscium). The distinctive asterism of **The Circlet** lies at the western end of the southern line of stars. The two north-south lines of the Great Square may be used as guides to other

constellations. The western line from **Scheat** (β Pegasi) through Markab, if extended about three times, crosses Aquarius and points to the bright, fairly isolated star, **Fomalhaut** (α Piscis Austrini) in the constellation of **Piscis Austrinus** and then onward to **Tiaki** (β Gruis) in the centre of a cross of stars within **Grus**. The eastern line, from Alpheratz through **Algenib** (γ Pegasi), extended about three-and-a-half times, indicates **Ankaa** (α Phoenicis) in the constellation of **Phoenix**.

The line between Markab and Algenib may be extended as an arc to lead to **Menkar** (α Ceti) in the 'tail' of Cetus. A line from Menkar through **Diphda** (β Ceti) also points to Fomalhaut in Piscis Austrinus. Diphda and Fomalhaut form the base of an almost perfect, large isoceles triangle, with **Achernar** (α Eridani) at the other apex. **Eridanus** itself is a long, trailing constellation that begins far to the north, near **Rigel** in **Orion**.

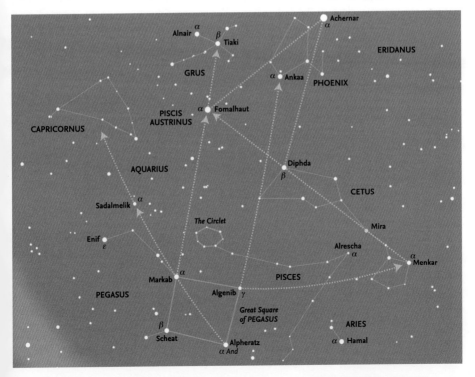

The Moon

The monthly pages include diagrams showing the phase of the Moon for every day of the month, and also indicate the day in the *lunation* (or *age* of the Moon), which begins at New Moon. Although the main features of the surface – the light highlands and the dark maria (seas) – may be seen with the naked eye, far more features may be detected with the use of binoculars or any telescope. The many craters are best seen when they are close to the *terminator* (the boundary between the illuminated and the non-illuminated areas of the surface), when the Sun rises or sets over any particular region of the Moon and the crater walls or central peaks cast strong shadows. Most features become difficult to see at Full Moon, although this is the best time to see the bright ray systems surrounding certain craters. Accompanying the Moon map on the following pages is a list of prominent features, including the days in the lunation when features are normally close to the terminator and thus easiest to see. A few bright features

such as Linné and Proclus, visible when well illuminated, are also listed. One feature, Rupes Recta (the Straight Wall) is readily visible only when it casts a shadow with light from the east, appearing as a light line when illuminated from the opposite direction.

The dates of visibility vary slightly through the effects of *libration*. Because the Moon's orbit is inclined to the Earth's equator and also because it moves in an ellipse, the Moon appears to rock slightly from side to side (and nod up and down). Features near the *limb* (the edge of the Moon) may vary considerably in their location and visibility. (This is easily noticeable with Mare Crisium and the craters Tycho and Plato.) Another effect is that at crescent phases before and after New Moon, the normally non-illuminated portion of the Moon receives a certain amount of light, reflected from the Earth. This *Earthshine* may enable certain bright features (such as Aristarchus, Kepler and Copernicus) to be detected even though they are not illuminated by sunlight.

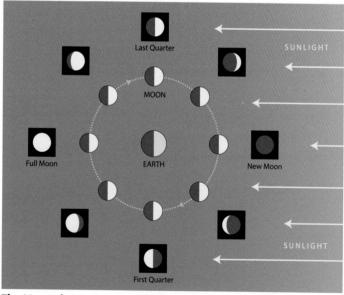

The Moon phases. *During its orbit around the Earth we see different portions of the illuminated side of the Moon's surface.*

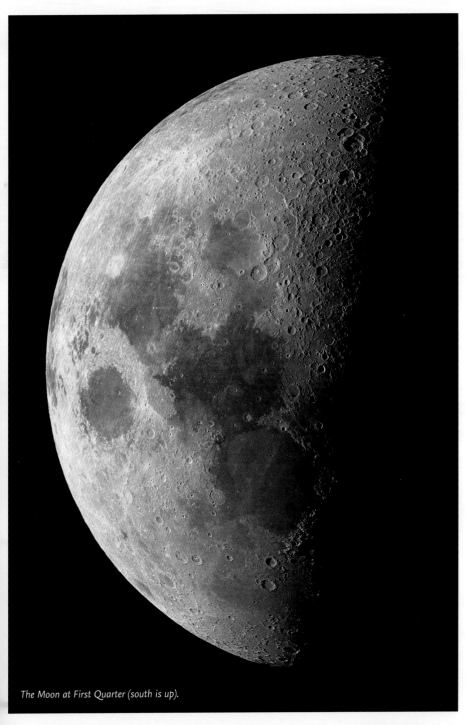

The Moon at First Quarter (south is up).

Map of the Moon

Abulfeda	6:20	
Agrippa	7:21	
Albategnius	7:21	
Aliacensis	7:21	
Alphonsus	8:22	
Anaxagoras	9:23	
Anaximenes	11:25	
Archimedes	8:22	
Aristarchus	11:25	
Aristillus	7:21	
Aristoteles	6:20	
Arzachel	8:22	
Atlas	4:18	
Autolycus	7:21	
Barrow	7:21	
Billy	12:26	
Birt	8:22	
Blancanus	9:23	
Bullialdus	9:23	
Bürg	5:19	
Campanus	10:24	
Cassini	7:21	
Catharina	6:20	
Clavius	9:23	
Cleomedes	3:17	
Copernicus	9:23	
Cyrillus	6:20	
Delambre	6:20	
Deslandres	8:22	
Endymion	3:17	
Eratosthenes	8:22	
Eudoxus	6:20	
Fra Mauro	9:23	
Fracastorius	5:19	
Franklin	4:18	
Gassendi	11:25	
Geminus	3:17	
Goclenius	4:18	
Grimaldi	13-14:27-28	
Gutenberg	5:19	
Hercules	5:19	
Herodotus	11:25	
Hipparchus	7:21	
Hommel	5:19	
Humboldt	3:15	
Janssen	4:18	
Julius Caesar	6:20	
Kepler	10:24	
Landsberg	10:24	
Langrenus	3:17	
Letronne	11:25	
Linné	6	
Longomontanus	9:23	

The numbers indicate the day or days (the age) of the Moon when features are usually best visible.

SOUTH

MARE AUSTRALE

Moretus · Manzinus · Curtius · Jacobi · Vlacq · Hommel · Pitiscus · Baco · Cuvier · Licetus · Maginus · Barocius · Saussure · Fabricius · Maurolycus · Nasireddin · Stöfler · Rheita · Metius · Riccius · Buch · Büsching · Orontius · Furnerius · Rabbi Levi · Nonius · Walther · Stevinus · Zagut · Aliacensis · Reichenbach · Pontanus · Werner · Regiomontanus · Snellius · Piccolomini · Apianus · Purbach · Humboldt · Sacrobosco · Blanchinus · Petavius · Azophi · Playfair · La Caille · Thebit · Santbech · Fracastorius · Abenezra · Beaumont · Geber · Arzachel · Vendelinus · Colombo · Catharina · Tacitus · Almanon · Airy · Argelander · Cyrillus · Abulfeda · Alphonsus · Kapteyn · Mädler · Theophilus · Albategnius · Goclenius · Ptolemaeus · Langrenus · Gutenberg · Isidorus · Capella · Hipparchus · Herschel · Torricelli · Hypatia · Delambre · Flammarion · Messier · A · Rhaeticus · Sabine · Ritter · Godin · Apollonius · Taruntius · Arago · Triesnecker · Bode · Firmicus · Hyginus · Agrippa · Menelaus · Manilius · Condorcet · Picard · Plinius · Vetruvius · Macrobius · Bessel · Cocon · Le Monnier · Linné · Cleomedes · Chacornac · Autolycus · Archimedes · Hahn · Burckhardt · Posidonius · Berosus · Geminus · Montes · Aristillus · Gauss · Franklin · Caucasus · Cepheus · Cassini · Atlas · Hercules · Bürg · Eudoxus · Mercurius · Aristoteles · Endymion · Arnold · W. Bond · Barrow · Meton · Goldschmidt

MARE NECTARIS
MARE FECUNDITATIS
MARE SPUMANS
MARE UNDARUM
MARE CRISIUM
PALUS SOMNI
MARE TRANQUILLITATIS
MARE VAPORUM
SINUS MEDII
MARE SERENITATIS
LACUS SOMNIORUM
PALUS PUTREDINIS
LACUS MORTIS
MARE FRIGORIS

Vallis Rheita · Montes Haemus · Montes Apenninus · Montes Alpes · Alpes Vallis

E

NORTH

18

SOUTH

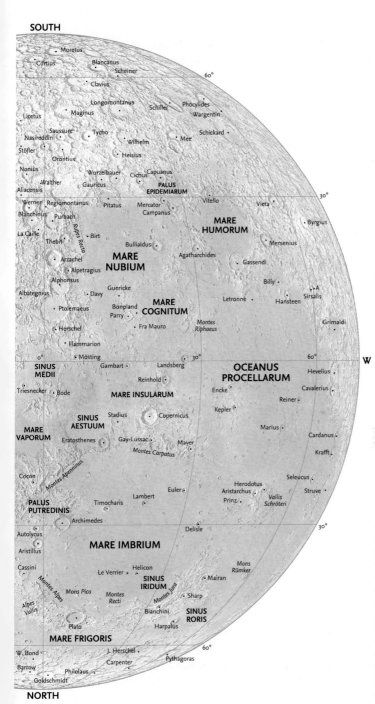

Macrobius	4:18
Mädler	5:19
Maginus	8:22
Manilius	7:21
Mare Crisium	2-3:16-17
Maurolycus	6:20
Mercator	10:24
Metius	4:18
Meton	6:20
Mons Pico	8:22
Mons Piton	8:22
Mons Rümker	12:26
Montes Alpes	6-8:21
Montes Apenninus	8
Orontius	8:22
Pallas	8:22
Petavius	3:17
Philolaus	9:23
Piccolomini	5:19
Pitatus	8:22
Pitiscus	5:19
Plato	8:22
Plinius	6:20
Posidonius	5:19
Proclus	14:18
Ptolemaeus	8:22
Purbach	8:22
Pythagoras	12:26
Rabbi Levi	6:20
Reinhold	9:23
Rima Ariadaeus	6:20
Rupes Recta	8
Saussure	8:22
Scheiner	10:24
Schickard	12:26
Sinus Iridum	10:24
Snellius	3:17
Stöfler	7:21
Taruntius	4:18
Thebit	8:22
Theophilus	5:19
Timocharis	8:22
Triesnecker	6-7:21
Tycho	8:22
Vallis Alpes	7:21
Vallis Schröteri	11:25
Vlacq	5:19
Walther	7:21
Wargentin	12:27
Werner	7:21
Wilhelm	9:23
Zagut	6:20

NORTH

Eclipses in 2024

Lunar eclipses

There are two lunar eclipses in 2024, one penumbral on March 25, with one partial eclipse on September 18. The penumbral eclipse is of minimal interest, mainly because to the naked eye it will show little variation in the Moon. During the first eclipse, on March 25, a very small portion of the Moon may enter the umbra. Maximum eclipse is at 07:12. The event (such as it is) will be visible in its totality from North America. During the second (partial) eclipse, on September 18, a slightly larger portion of the Moon will enter the umbra, beginning at 02:14 and leaving at 03:16, with maximum eclipse at 02:44. The middle and end of this eclipse will be just visible from the eastern seaboard of the United States.

Solar eclipses

There are two solar eclipses in 2024. The total eclipse of April 8 is the most significant. The path of totality passes across the southern United States and is shown on the map below. Maximum eclipse actually occurs in Mexico at 18:17, where the duration is 4 minutes 28.1 seconds, but the path of totality runs all the way from Texas to Nova Scotia and Newfoundland in Canada, ending in the North Atlantic.

The second solar eclipse on October 2 is an annular eclipse, mainly visible over the Pacific Ocean, although the end of the track does pass across southern Chile and Argentina. Although most of the track passes over the open ocean, it will cross Rapa Nui (Easter Island, at 27°7'S, 109°22'W) where the annular phase will be visible and last over six minutes. Maximum eclipse occurs at 18:46.

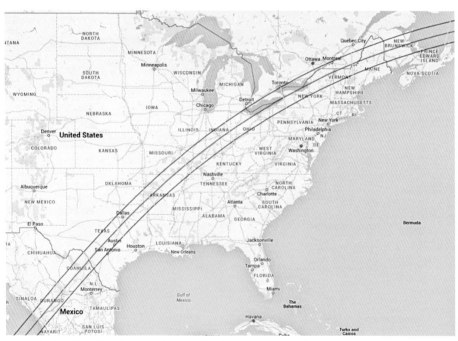

The total solar eclipse of April 8, 2024. The path of totality sees maximum eclipse duration occur in Mexico, before the track enters the United States in Texas. The path runs right across the United States, with the ground track ending in Nova Scotia and Newfoundland in Canada.

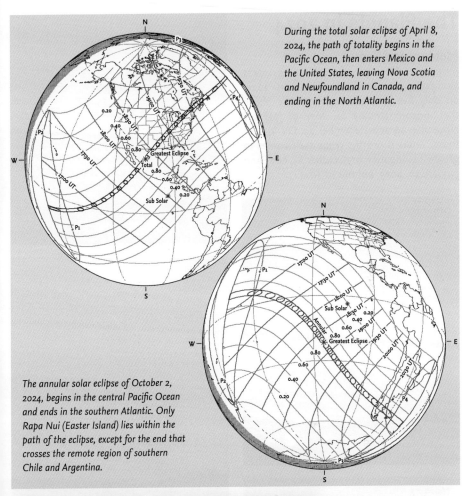

During the total solar eclipse of April 8, 2024, the path of totality begins in the Pacific Ocean, then enters Mexico and the United States, leaving Nova Scotia and Newfoundland in Canada, and ending in the North Atlantic.

The annular solar eclipse of October 2, 2024, begins in the central Pacific Ocean and ends in the southern Atlantic. Only Rapa Nui (Easter Island) lies within the path of the eclipse, except for the end that crosses the remote region of southern Chile and Argentina.

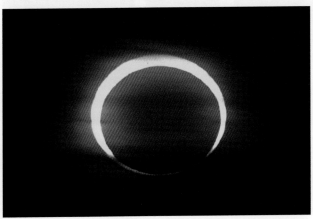

An annular eclipse of the Sun, photographed from California, towards the end of the eclipse at sunset over the Pacific.

The Planets in 2024

Mercury and Venus

Although **Mercury** comes to greatest elongation on seven occasions in 2024, on only five is it reasonably visible above the horizon: January 12, May 9, July 22, November 16 and December 25. On four of these, Venus is nearby. **Venus** itself comes to greatest elongation on October 23, 2023 and January 10, 2025, but not in 2024.

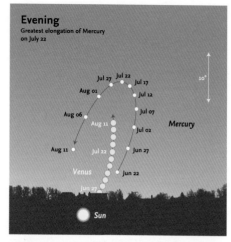

Evening
Greatest elongation of Mercury on July 22

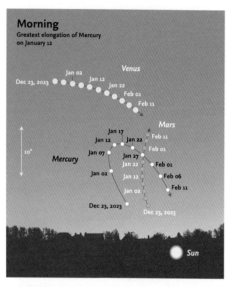

Morning
Greatest elongation of Mercury on January 12

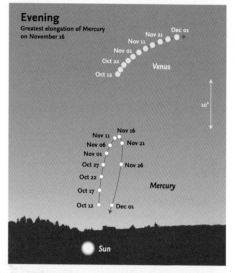

Evening
Greatest elongation of Mercury on November 16

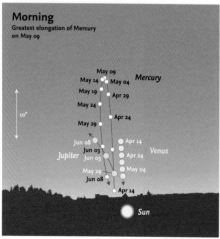

Morning
Greatest elongation of Mercury on May 09

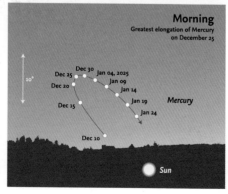

Morning
Greatest elongation of Mercury on December 25

The path of Mars in 2024. In the first months it is too close to the Sun to be readily observed.

Mars

Because its orbit lies outside that of the Earth, so taking longer to complete an orbit, Mars does not come to opposition every year. Instead it often remains in the sky for many months at a time, moving slowly along the ecliptic. This is the case in 2024, when there is no opposition, but the planet is visible from March to December, as shown in the large chart here. (In January and February it is too close to the Sun to be readily visible.) It is mag. 1.3 in **Capricornus** in March, but slowly increases to mag. 1.0 in June and July, in **Pisces** and **Aries**. It ends the year in **Cancer** at mag. -1.2.

Oppositions occur during a period of retrograde motion, when the planet appears to move westwards against the pattern of distant stars. There is no opposition in 2024. Mars actually begins to retrograde on December 9, 2024, and comes to its next opposition on January 16, 2025.

Because of its eccentric orbit, which carries it at very differing distances from the Sun (and Earth), not all oppositions of Mars are equally favorable for observation. The relative positions of Mars and the Earth are shown here. It will be seen that the opposition of 2018 was very close and thus favorable for observation, and that of 2020 was also reasonably good. By comparison, opposition in 2027 will be at a far greater distance, so the planet will appear much smaller.

This image of Mars was obtained by Damian Peach with a 14-inch Celestron telescope on September 30, 2020 when Mars was magnitude -2.5. South is at the top.

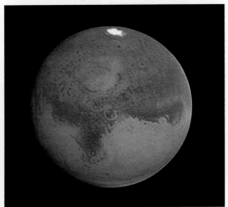

The oppositions of Mars between 2018 and 2033. As the illustration shows, there is no opposition in 2024.

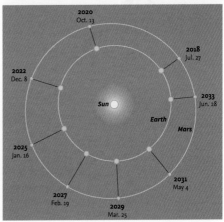

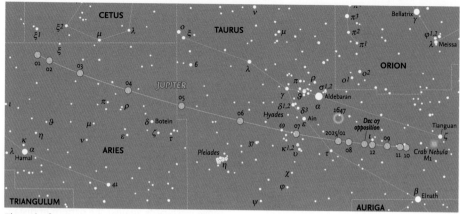

The path of Jupiter in 2024. Jupiter comes to opposition on December 7. Background stars are shown down to magnitude 6.5. South is up on all maps.

Jupiter and Saturn

In 2024, **Jupiter** starts the year in **Aries**, begining in the west. It moves into **Taurus** in late April. It begins to retrograde in October 9 and comes to opposition, still in Taurus, on December 7 at mag. -2.8. It continues retrograde motion to the end of the year. **Saturn** is in **Aquarius** and stays there for the whole year. It starts retrograde motion on 4 July and comes to opposition at mag. 0.6 on September 8. It continues slow retrograde motion until November 16. At the end of the year it is mag. 1.1.

Jupiter's four large satellites are readily visible in binoculars. Not all four are visible all the time, sometimes hidden behind the planet or invisible in front of it. **Io**, the closest to Jupiter, orbits in just under 1.8 days, and **Callisto**, the farthest away, takes about 16.7 days. In between are **Europa** (c. 3.6 days) and **Ganymede**, the largest (c. 7.1 days). The diagram (below) shows the satellites' motions around the time of opposition.

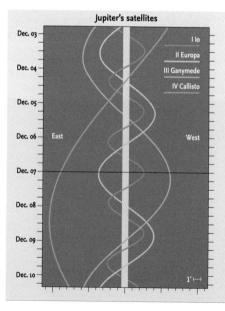

The path of Saturn in 2024. Saturn comes to opposition on September 8. Background stars are shown down to magnitude 6.5.

Uranus and Neptune

Uranus begins the year in **Aries** at mag. 5.7, and moves into **Taurus** in late May. It begins retrograde motion in early September and is at opposition (mag. 5.6) on November 17. It continues retrograde motion and is on the **Taurus/Aries** border at the end of the year.

Neptune begins the year just north of the border between **Aquarius** and **Pisces**. It starts its retrograde motion in early July, and is at opposition (mag. 7.8) on September 21. Still in **Pisces** (at mag. 7.9), it reverts to direct motion at the very end of the year.

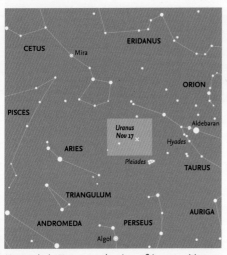

Uranus is in Taurus at the time of its opposition, on November 17. The boxed area is shown in more detail to the right.

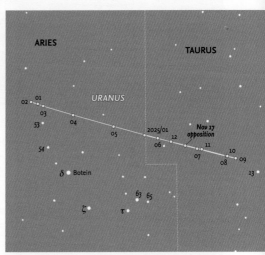

The path of Uranus in 2024. Uranus comes to opposition on November 17. All stars brighter than magnitude 7.5 are shown.

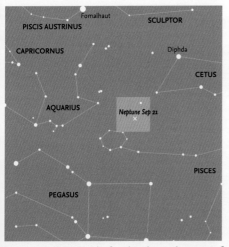

In 2024, Neptune is to be found in the southern part of Pisces. The planet comes to opposition on September 21.

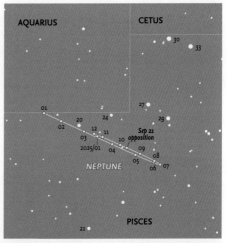

The path of Neptune in 2024. It is in the constellation of Pisces, for the whole year. All stars down to magnitude 8.5 are shown.

Minor Planets in 2024

Several minor planets rise above magnitude 9 in 2024, and four come to opposition at, or above mag. 9.0. These are *(3) Juno* in *Leo* on March 3 when it is mag. 8.7; *(1) Ceres* in *Sagittarius* on July 6, at mag. 7.3, *(7) Iris* in *Aquarius* on August 6 (mag. 8.1) and *(15) Eunomia* in *Auriga* at mag. 8.0 on December 14.

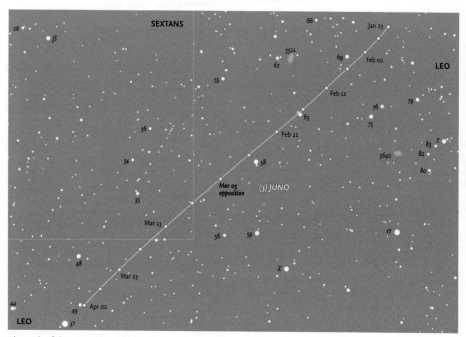

The path of the minor planet (3) Juno around its opposition on March 3 (mag. 8.7). Background stars are shown down to magnitude 9.5. South is up on all charts on these pages.

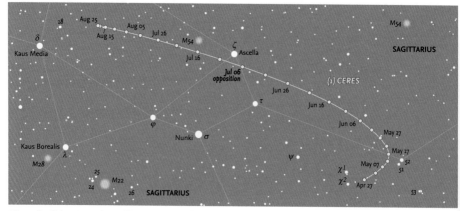

The path of the minor planet (1) Ceres around its opposition on July 6 (mag. 7.3). Background stars are shown down to magnitude 8.5.

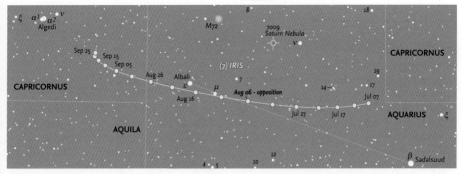

The path of the minor planet (7) Iris around its opposition on August 6 (mag. 8.1). Background stars are shown down to magnitude 9.0.

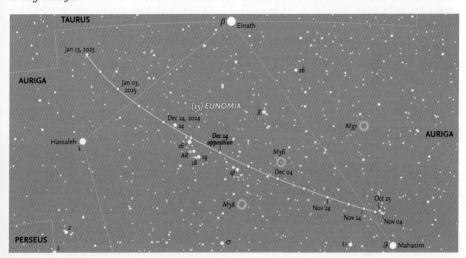

The path of the minor planet (15) Eunomia around its opposition on December 14 (mag. 8.0). Background stars are shown down to magnitude 9.0.

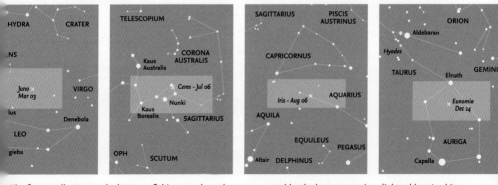

The four small maps at the bottom of this page show the areas covered by the larger maps in a lighter blue. A white cross marks the position of the minor planet at the day of its opposition.

Comets in 2024

Although comets may occasionally become very striking objects in the sky, as was the case with Comet C/2020 F3 NEOWISE in 2020, their occurrence and particularly the existence or length of any tail and their overall magnitude are notoriously difficult to predict. Naturally, it is only possible to predict the return of periodic comets (whose names have the prefix 'P'). Many comets appear unexpectedly (these have names with the prefix 'C'). Bright, readily visible comets such as C/1995 Y1 Hyakutake, C/1995 O1 Hale-Bopp, C/2006 P1 McNaught or C/2020 F3 NEOWISE are rare. Most periodic comets are faint and only a very small number

ever become bright enough to be easily visible with the naked eye or with binoculars.

Comet 62P/Tsuchinshan 1, visible in November and December 2023, may continue to be seen (although fading) in early 2024.

The comet most likely to become readily visible in 2024 is Comet 12P/Pons-Brooks, which may reach mag. 5 during late March or even mag. 4 at the beginning of April. This is a 'Halley-type' comet, with an orbital period of 68.82 years. It last came to perihelion on May 22, 1954.

Another comet, C/2021 S3 (PanSTARRS) may rise as high as mag. 7 during April, but is unlikely to become a prominent object.

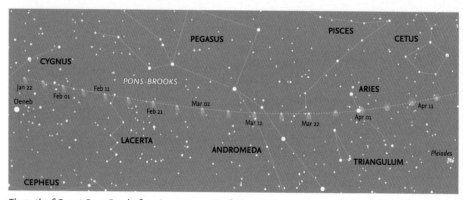

The path of Comet Pons-Brooks from January 22 to April 16, 2024. It rises above magnitude 4 in April. Background stars are shown down to magnitude 6.0. South is up.

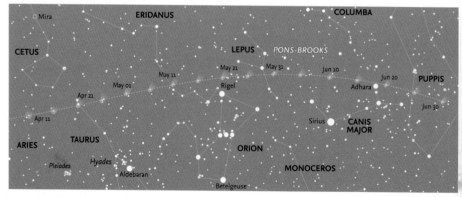

The path of Comet Pons-Brooks from April 11 to June 30, 2024. It rises above magnitude 4 in April. Background stars are shown down to magnitude 6.0. South is up.

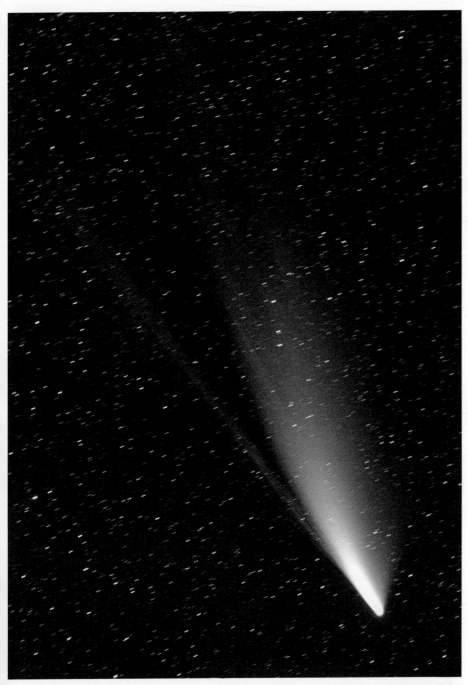

The Comet C/2020 F3 NEOWISE photographed by Nick James on July 17, 2020, showing the light-coloured dust tail, together with the blue ion tail.

Introduction to the Month-by-Month Guide

The monthly charts

The pages devoted to each month contain a pair of charts showing the appearance of the night sky, looking south and looking north. The charts (as with all the charts in this book) are drawn for the latitude of 35°S, so observers farther north will see slightly more of the sky on the northern horizon, and slightly less on the southern, with corresponding changes if they are farther south. The horizon areas are, of course, those most likely to be affected by poor observing conditions caused by haze, mist or smoke. In addition, stars close to the horizon are always dimmed by atmospheric absorption, so sometimes the faintest stars marked on the charts may not be visible.

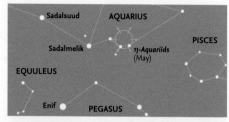

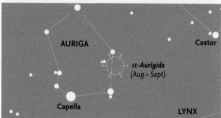

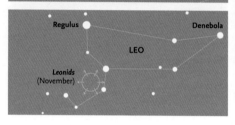

The three times shown for each chart require a little explanation. The charts are drawn to show the appearance at 11 p.m. for the 1st of each month. The same appearance will apply an hour earlier (10 p.m.) on the 15th, and yet another hour earlier (9 p.m.) at the end of the month (shown as the 1st of the following month). Daylight Saving Time (DST) is not used in South Africa. In New Zealand, it applies from the last Sunday of September to the first Sunday of April. In those Australian states with DST, it runs from the first Sunday in October to the first Sunday in April. The appropriate times are shown on the monthly charts. Times of specific events are shown on the 24-hour clock of Universal Time (UT), used by astronomers worldwide, and corrections for the local time zone (and DST where employed) may be found from the details inside the front cover.

The charts may be used for earlier or later times during the night. To observe two hours earlier, use the charts for the preceding month; for two hours later, the charts for the next month.

Meteors

Details of specific meteor showers are given in the months when they come to maximum, regardless of whether they begin or end in other months. Note that not all the respective radiants are marked on the charts for that particular month, because the radiants may be below the horizon, or lie in constellations that are not readily visible during the month of maximum. For this reason, special charts for the Eta (η) Aquariids (May), the Alpha (α) Aurigids (August and September) and the Leonids (November) are given here. As just explained, however, meteors from such showers may still be seen, because the most effective region for seeing meteors is some 40–45° away from the radiant, and that area of sky may be well above the horizon. A table of the best meteor showers visible during the year is also given here. The rates given are based on the properties of the meteor streams, and are those that an experienced observer might see under ideal conditions. Generally, the observed rates will be far less.

Shower	Dates of activity 2024	Date of maximum 2024	Possible hourly rate
α-Centaurids	January 31 to February 20	February 8	6
γ-Normids	February 25 to March 28	March 14–15	6
π-Puppids	April 15 to April 28	April 23–24	var.
η-Aquariids	April 19 to May 28	May 6	50
α-Capricornids	July 3 to August 15	July 30	5
Southern δ-Aquariids	July 12 to August 23	July 30	25
Piscis Austrinids	July 15 to August 10	July 28	5
Perseids	July 17 to August 24	August 12–13	100
α-Aurigids	August 28 to September 5	September 1	6
Southern Taurids	September 10 to November 20	October 10–11	5
Orionids	October 2 to November 7	October 21–22	20
Northern Taurids	October 20 to December 10	November 12–13	5
Leonids	November 6 to November 30	November 18	10
Phoenicids	November 28 to December 9	December 2	var.
Puppid Velids	December 1 to December 15	December 7	10
Geminids	December 4 to December 20	December 14–15	150

Meteors that are brighter than magnitude -4 (approximately the maximum magnitude reached by Venus) are known as *fireballs* or *bolides*.

The photographs

As an aid to identification – especially as some people find it difficult to relate charts to the actual stars they see in the sky – one or more photographs of constellations visible in certain specific months are included. It should be noted, however, that because of the limitations of the photographic and printing processes, and the differences between the sensitivity of different individuals to faint starlight (especially in their ability to detect different colours), and the degree to which they have become adapted to the dark, the apparent brightness of stars in the photographs will not necessarily precisely match that seen by any one observer.

The Moon calendar

The Moon calendar is largely self-explanatory. It shows the phase of the Moon for every day of the month, with the exact times (in Universal Time) of New Moon, First Quarter, Full Moon and Last Quarter. Because the times are calculated from the Moon's actual orbital parameters, some of the times shown will, naturally, fall during daylight, but any difference is too small to affect the appearance of the Moon on that date. Also shown is the

age of the Moon (the day in the *lunation*), beginning at New Moon, which may be used to determine the best time for observation of specific lunar features.

The Moon

The section on the Moon includes details of any lunar or solar eclipses that may occur during the month (visible from anywhere on Earth). Similar information is given about any important occultations. Mainly, however, this section summarizes when the Moon passes close to planets or the five prominent stars close to the ecliptic. The dates when the Moon is closest to the Earth (at *perigee*) and farthest from it (at *apogee*) are shown in the monthly calendars, and only mentioned here when they are particularly significant, such as the nearest and farthest during the year

The planets and minor planets

Brief details are given of the location, movement and brightness of the planets from Mercury to Saturn throughout the month. None of the planets can, of course, be seen when they are close to the Sun, so such periods are generally noted. All of the planets may sometimes lie on the opposite side of the Sun to the Earth (at superior conjunction), but in the case of the inferior planets, Mercury and Venus, they may also pass between the Earth and the Sun (at inferior conjunction)

A fireball (with flares approximately as bright as the Full Moon), photographed against a weak auroral display by D. Buczynski from Tarbat Ness in Scotland on January 22, 2017.

and are normally invisible for a longer or shorter period of time. Those two planets are normally easiest to see around either eastern or western elongation, in the evening or morning sky, respectively. Not every elongation is favourable, so although every elongation is listed, only those where observing conditions are favourable are shown in the individual diagrams of events.

The dates at which the superior planets reverse their motion (from direct motion to retrograde, and retrograde to direct) and of opposition (when a planet generally reaches its maximum brightness) are given. Some planets, especially distant Saturn, may spend most or all of the year in a single constellation. Jupiter and Saturn are normally easiest to see around opposition, which occurs every year. Mars, by contrast, moves relatively rapidly against the background stars and in some years never comes to opposition. In 2020, Jupiter and Saturn are close together in the sky throughout the year, so a special chart is shown on page 24.

Uranus is normally magnitude 5.7–5.9, and thus at the limit of naked-eye visibility under exceptionally dark skies, but bright enough to be readily visible in binoculars. Because its orbital period is so long (over 84 years), Uranus moves only slowly along the ecliptic, and often remains within a single constellation for a whole year. The chart on page 25 shows its position during 2024.

Similar considerations apply to Neptune, although it is always fainter (generally magnitude 7.8–8.0), still visible in most binoculars. It takes about 164.8 years to complete one orbit of the Sun. As with Uranus, it frequently spends a complete year in one constellation. Its chart is also on page 25.

In any year, few minor planets ever become bright enough to be detectable in binoculars. Just one, (4) Vesta, on rare occasions brightens sufficiently for it to be visible to the naked eye. Our limit for visibility is magnitude 9.0 and details and charts are given for those objects that exceed that magnitude during the year, normally around opposition. To assist in recognition of a planet or minor planet as it moves against the background stars, the latter are shown to a fainter magnitude than the object at opposition. Minor-planet charts for 2024 are on pages 26 and 27.

The ecliptic charts

Although the ecliptic charts are primarily designed to show the positions and motions of the major planets, they also show the motion of the Sun during the month. The light-tinted area shows the area of the sky that is invisible during daylight, but the darker area gives an indication of which constellations are likely to be visible at some time of the night. The closer a planet is to the border between dark and light, the more difficult it will be to see in the twilight.

The monthly calendar

For each month, a calendar shows details of significant events, including when planets are close to one another in the sky, close to the Moon, or close to any one of five bright stars that are spaced along the ecliptic. The times shown are given in Universal Time (UT), always used by astronomers throughout the year, and which is identical to Greenwich Mean Time (GMT). So during the summer months, they do not show Summer Time, which will need to be taken for the observing location.

The diagrams of interesting events

Each month, a number of diagrams show the appearance of the sky when certain events take place. However, the exact positions of celestial objects and their separations greatly depend on the observer's position on Earth. When the Moon is one of the objects involved, because it is relatively close to Earth, there may be very significant changes from one location to another. Close approaches between planets or between a planet and a star are less affected by changes of location, which may thus be ignored.

The diagrams showing the appearance of the sky are drawn at latitude 35°S and longitude 150°E (approximately that of Sydney, Australia), so will be approximately correct for much of Australia. However, for an observer farther north (say, Brisbane or Darwin), a planet or star listed as being north of the Moon will appear even farther north, whereas one south of the Moon will appear closer to it – or may even be hidden (occulted) by it. For an observer at a latitude greater than 35°S (such as in New Zealand), there will be corresponding changes in the opposite direction: for a star or planet south of the Moon, the separation will increase, and for one north of the Moon, the separation will decrease. This is particularly important when occultations occur, which may be visible from one location, but not another. There are eight occultations of Saturn in 2024. Seven of these are visible from the southern hemisphere (see the monthly calendars for more details).

Ideally, details should be calculated for each individual observer, but this is obviously impractical. In fact, positions and separations are actually calculated for a theoretical observer located at the centre of the Earth.

So the details given regarding the positions of the various bodies should be used as a guide to their location. A similar situation arises with the times that are shown. These are calculated according to certain technical criteria, which need not concern us here. However, they do not necessarily indicate the exact time when two bodies are closest together. Similarly, dates and times are given, even if they fall in daylight, when the objects are likely to be completely invisible. However, such times do give an indication that the objects concerned will be in the same general area of the sky during both the preceding and the following nights.

Data used in this Guide

The data given in this Guide, such as timings and distances between objects, have been computed with a program developed by the US Naval Observatory in Washington DC (MICA, the Multiyear Interactive Computer Almanac), widely regarded as the most accurate computation. As such, the data may differ slightly from information given elsewhere.

Key to the symbols used on the monthy star maps.

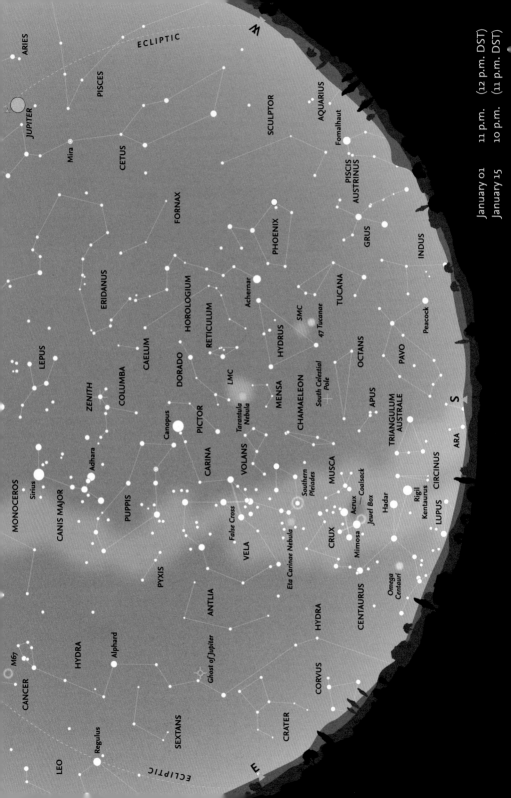

January – Looking South

Crux is now quite prominent as it rises in the east, and even **Rigil Kentaurus** and **Hadar** (α and β Centauri), although low, are becoming easier to see. The whole of **Carina** is visible, with both the **Eta Carinae Nebula** and the **Southern Pleiades** between Crux and the **False Cross** of stars from the constellations of Carina and **Vela. Canopus** (α Carinae) is high in the south, roughly three-quarters of the way from the horizon to the zenith. Also in the south, but slightly lower, is the **Large Magellanic Cloud** (LMC). **Achernar** (α Eridani) is prominent between the constellations of **Hydrus** and **Phoenix**. The **Small Magellanic Cloud** (SMC) and **47 Tucanae** are well-placed for observation alongside Hydrus. **Fomalhaut** (α Piscis Austrini) may be glimpsed low on the horizon towards the west as may **Peacock** (α Pavonis) farther towards the south. The whole of **Pavo** and **Grus** is visible, together with most of **Indus.**

Meteors

The year does not start well for southern meteor observers. The **α-Centaurids** (active late January to February) have low maximum rates, as do the **γ-Normids** (February to March). Only with the **π-Puppids** (maximum April 23–24) is there any likelihood of a higher rate of about 40, although even that is rare. The **Southern δ-Aquarids** (maximum July 30) have a rate of about 25 per hour, as do the **Orionids** (Maximum October 21-22). Only with the **Leonids** (maximum November 18) is there a rate of 10 per hour. The **Phoenicids** in November–December (maximum December 2) are unpredictable, but may show strong activity. The last major shower of the year, the **Geminids** (maximum December 14–15) finally achieves a rate of about 120 or even 150 per hour.

Part of the southern Milky Way. The two bright stars near the bottom of the image are α and β Centauri. The constellation of Crux is near the centre. The Eta Carinae Nebula and the Southern Pleiades are near the top-right corner.

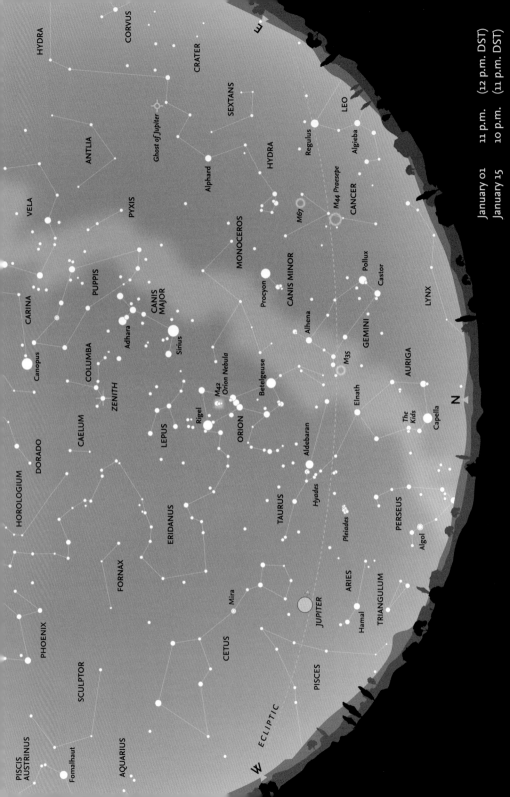

January – Looking North

The northern sky is dominated by **Orion**, prominent during the summer months and visible at some time during the night. It is highly distinctive, with a line of three stars that form the 'Belt'. To most observers, the bright star **Betelgeuse** (α Orionis), shows a reddish tinge, in contrast to the brilliant bluish-white **Rigel** (β Orionis). The three stars of the belt lie directly south of the celestial equator. A vertical line of three 'stars' forms the 'Sword' that hangs south of the Belt. With good viewing, the central 'star' appears as a hazy spot, even to the naked eye, and is actually the **Orion Nebula**. Binoculars reveal the four stars of the Trapezium, which illuminate the nebula.

Orion's Belt points down to the northwest towards **Taurus** (the Bull) and orange-tinted **Aldebaran** (α Tauri). Close to Aldebaran, there is a conspicuous 'V' of stars, called the **Hyades** cluster. (Despite appearances, Aldebaran is not part of the cluster.) Farther along, the same line from Orion passes above a bright cluster of stars, the **Pleiades**, or Seven Sisters. Even the smallest pair of binoculars reveals this as a beautiful group of bluish-white stars. The two most conspicuous of the other stars in Taurus lie directly below Orion, and form an elongated triangle with Aldebaran. The northernmost, **Elnath** (β Tauri), was once considered to be part of the constellation of **Auriga**.

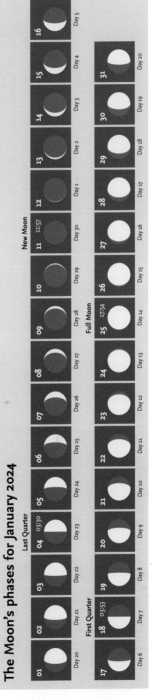

The constellation of Orion dominates the northern sky during this period of the year, and is a useful starting point for recognizing other constellations in the area (see page 36). Here, orange Betelgeuse, blue-white Rigel and the pinkish Orion Nebula are prominent (south is up).

The Moon's phases for January 2024

01 Day 20	02 Day 21	03 Day 22	04 03:30 Day 23	05 Day 24	06 Day 25	07 Day 26	08 Day 27
			Last Quarter				

First Quarter

Last Quarter

New Moon

Full Moon

| 17 03:53 Day 6 | 18 03:53 Day 7 | 19 Day 8 | 20 Day 9 | 21 Day 10 | 22 Day 11 | 23 Day 12 | 24 Day 13 |

| 09 Day 28 | 10 Day 29 | 11 11:57 Day 30 | 12 Day 1 | 13 Day 2 | 14 Day 3 | 15 Day 4 | 16 Day 5 |

| 25 17:54 Day 14 | 26 Day 15 | 27 Day 16 | 28 Day 17 | 29 Day 18 | 30 Day 19 | 31 Day 20 | |

January – Moon and Planets

The Earth

The Earth reaches perihelion (the closest point to the Sun in its yearly orbit) on January 3 at 03:39 Universal Time, when it is at a distance of 0.98306994 AU (147,101,081 km).

The Moon

On January 4, at Last Quarter, the Moon is 2°N of *Spica* in *Virgo*. On January 8 it passes 0.8°N of *Antares*, and a few hours later, is 5.7°S of *Venus*. It passes a similar distance south of *Mercury* the next day, and 4.2°S of *Mars* on January 10. On January 14, the waxing crescent Moon is 2.1°S of *Saturn*, and just 1.0°S of *Neptune* the next day. At First Quarter, the Moon is 1.8°N of *Jupiter* and 3.0°N of much fainter *Uranus* the following day. It then passes 9.5°N of *Aldebaran* on January 21.

By January 24, a day before Full Moon, it is 1.7°S of *Pollux*. On January 27 the Moon passes 3.9°N of *Regulus*, between it and *Algieba*.

The planets

Mercury comes to western elongation on January 12 (see the diagram on page 22). *Venus* is bright (mag. -4.0), not far from Mercury in the morning sky. *Mars* (mag. 1.3 to 1.4) is in the same area, but lower in the sky. *Jupiter* (mag. -2.4 to -2.5) is in southern *Aries* and *Saturn* (mag. 1.0) is in *Aquarius*. *Uranus* (mag. 5.7) is in *Aries* and *Neptune* (mag. 7.9) in *Pisces*.

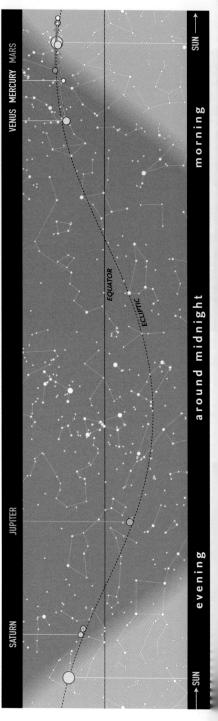

The path of the Sun and the planets along the ecliptic in January.

01	15:28	Moon at apogee = 404,909 km
03	03:39	Earth at perihelion (147,101,081 km = 0.9833 AU)
04	03:30	Last Quarter
04	23:48	Spica 2.0°S of the Moon
08	14:59	Antares 0.8°S of the Moon
08	20:10	Venus (mag. -4.0) 5-7°N of the Moon
09	18:47	Mercury (mag. -0.2) 6.6°N of the Moon
10	08:31	Mars (mag. 1.4) 4.2°N of the Moon
11	11:57	New Moon
12	14:37	Mercury at greatest elongation (23.5°W, mag. -0.3)
13	10:36	Moon at perigee = 263,267 km
14	09:33	Saturn (mag. 1.0) 2.1°N of the Moon
15	20:25	Neptune (mag. 7.9) 1.0°N of the Moon
18	03:53	First Quarter
18	20:42	Jupiter (mag. -2.5) 1.8°S of the Moon
19	19:39	Uranus (mag. 5.7) 3.0°S of the Moon
21	11:06	Aldebaran 9.5°S of the Moon
24	19:39	Pollux 1.7°N of the Moon
25	17:54	Full Moon
27	16:00 *	Mars (mag. 1.3) 0.2°S of Mercury (mag. -0.2)
27	16:59	Regulus 3.9°S of the Moon
29	08:14	Moon at apogee = 405,777 km
31–Feb.20		α-Centaurid meteor shower

* These objects are close together for an extended period around this time.

Morning 3 a.m. (DST)

January 5–6 • In the east, the Moon passes Spica, shortly after Last Quarter.

Morning 5:30 a.m. (DST)

January 9–11 • In the morning twilight, the narrow crescent Moon passes Venus, Mercury and Mars.

Evening 9 p.m. (DST)

January 14 • The Moon with Saturn, side-by-side in the west.

Evening 11 p.m. (DST)

January 18–20 • The Moon is waxing gibbous, when it passes Jupiter, Hamal and the Pleiades.

Evening 11 p.m. (DST)

January 24 • The nearly Full Moon forms a nice triangle with Pollux and Castor.

Morning 6 a.m. (DST)

January 28 • Early in the Morning, the Moon is between Regulus and Algieba.

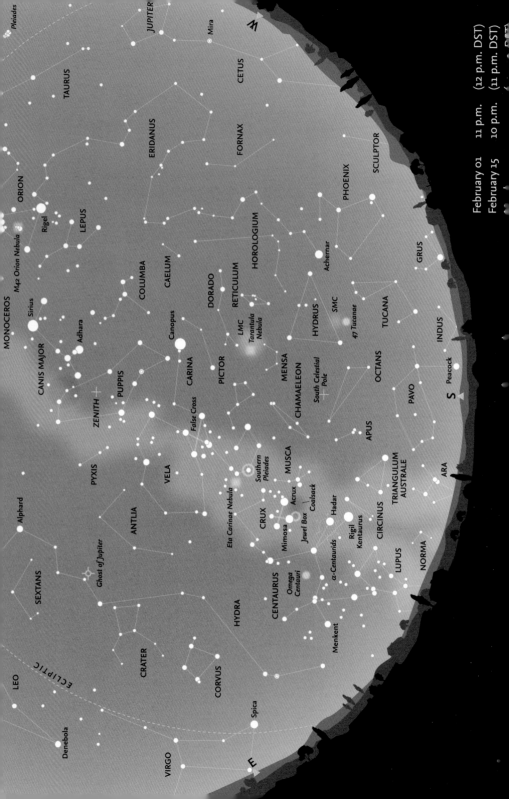

February – Looking South

The whole of **Centaurus** is now clear of the horizon in the southeast, where, below it, the constellation of **Lupus** is beginning to be visible. **Triangulum Australe** is now higher in the sky and easier to see. Both **Crux** and the **False Cross** are also higher and more visible. The **Large Magellanic Cloud** (LMC) and brilliant **Canopus** are now almost due south, with the constellation of **Puppis** at the zenith. Both **Hydrus** and the **Small Magellanic Cloud** (SMC) are lower in the sky, as is **Phoenix**, which is much closer to the horizon in the west. Next to it, the constellation of **Tucana** is also lower although the globular cluster **47 Tucanae** remains readily visible as does **Achernar** (α Eridani). The constellation of **Grus** and bright **Fomalhaut** (α Piscis Austrini) have disappeared below the horizon. **Peacock** (α Pavonis) is skimming the horizon in the south and is not easily seen at any time in the night.

Meteors

The **Centaurid** shower (which actually consists of two separate streams: the **α- and β-Centaurids**, with both radiants lying near α and β Centauri (Rigil Kentaurus and Hadar, respectively) continues in February, reaching a low maximum (around 6 meteors per hour) on February 8, when the Moon is a waning crescent, just before New Moon. Another weak shower, the **γ-Normids**, begins to be active in late February (February 25), but the meteors are difficult to differentiate from sporadics. It reaches its weak (but sharp) maximum on March 14–15.

Parts of Carina and Vela. The 'False Cross' is indicated with blue lines. The red blurry spot near the bottom-left corner is the Eta (η) Carinae Nebula. To the right, and a little lower, is an open cluster that surrounds Theta (ϑ) Carinae. This cluster (IC 2602) is also known as the Southern Pleiades.

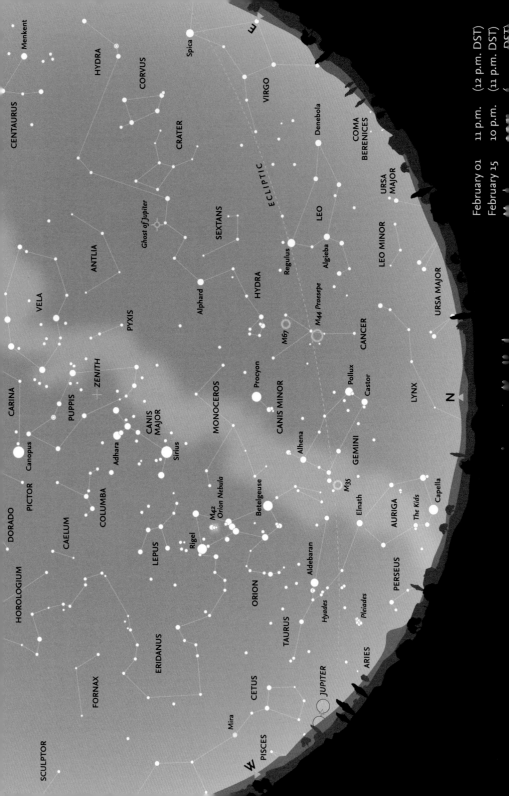

February – Looking North

The constellation of **Gemini**, with the pair of stars **Castor** and **Pollux** (α and β Geminorum) is now due north. Pollux is higher in the sky (farther towards the zenith), and above it is **Procyon** (α Canis Minoris), halfway to the zenith. Still higher is **Sirius**, the brightest star in the sky and the constellation of **Canis Major**. The faint constellation of **Cancer**, with its most noticeable feature, the cluster **Praesepe**, lies to the east of Gemini. Above it, and directly east of Procyon, is the distinctive asterism forming the head of **Hydra**, the whole of which constellation is now visible stretching across the sky towards the east. The constellation of **Taurus**, with orange **Aldebaran** (α Tauri) is still clearly seen in the west. By contrast, **Auriga** is much lower towards the horizon and brilliant **Capella** (α Aurigae) is extremely low and visible only early in the night. The faintest stretch of the Milky Way runs from Auriga in the northwest up towards the zenith, passing through Gemini and the indistinct constellation of **Monoceros**. In the northeast, the zodiacal constellation of **Leo** and bright **Regulus** (α Leonis) are clearly seen.

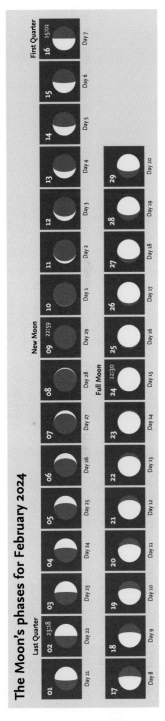

The constellation of Cancer. Almost at the centre of the image is the open star cluster M44 (Praesepe), sometimes called the 'Beehive'. The faint constellation of Cancer is surrounded by several bright stars: Castor and Pollux, near the bottom, Procyon near the top and Regulus with Algieba close to the right edge of the image (south is up).

The Moon's phases for February 2024

Last Quarter

01	02 23:18	03	04	05	06	07
Day 21	Day 22	Day 23	Day 24	Day 25	Day 26	Day 27

New Moon

08	09 22:59
Day 28	Day 29

First Quarter

10	11	12	13	14	15	16 15:01
Day 1	Day 2	Day 3	Day 4	Day 5	Day 6	Day 7

Full Moon

17	18	19	20	21	22	23	24 12:30
Day 8	Day 9	Day 10	Day 11	Day 12	Day 13	Day 14	Day 15

25	26	27	28	29	
Day 16	Day 17	Day 18	Day 19	Day 20	

44

February – Moon and Planets

The Moon

On February 1 the Moon, just before Last Quarter, is 1.7°N of *Spica* in *Virgo*. By February 5 it is 0.6°N of orange-red *Antares*. One day later it is 5.4°S of brilliant *Venus*. It passes 4.2°S of *Mars* the next day and 3.2°S of *Mercury* later that day. Two days after New Moon (by February 11) the Moon is 1.8°S of *Saturn* and the next day is even closer (0.7°S) to the much fainter *Neptune*. Three days later (February 15) the Moon is 3.2°N of *Jupiter* and the next day the same distance north of *Uranus*. On February 17, one day after First Quarter, the Moon is 9.8°N of *Aldebaran* in *Taurus*. By February 21, it is 1.6°S of *Pollux*, three days before Full Moon. On February 23, the Moon is 3.6°N of *Regulus*, passing between it and *Algieba*.

Occultations

Although there are as many as 14 occultations of *Antares* in 2024 and 9 of *Spica*, none are readily visible from land, visible (if at all) from the oceans. There are no occultations in 2024 of the other bright stars (*Aldebaran*, *Pollux* and *Regulus*) near the ecliptic.

The planets

Mercury is 3.2°N of the Moon on February 8, one day before New Moon. *Venus* remains bright (mag. -3.9) in the morning sky, but is becoming lower towards the horizon. *Mars* is too close to the Sun to be readily visible. *Jupiter* is moving slowly in *Aries* at mag. -2.3 to -2.2. *Saturn* (mag. 1.0) remains in *Aquarius. Uranus* (mag. 5.7 to 5.8) is in *Aries* and *Neptune* (mag. 7.9 to 8.0) in *Pisces*.

The path of the Sun and the planets along the ecliptic in February.

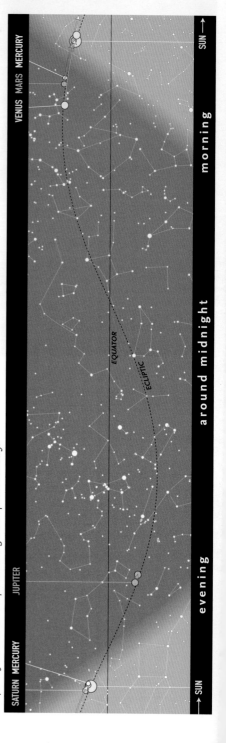

Calendar for February

01	07:46	Spica 1.7°S of the Moon
02	23:18	Last Quarter
05	00:52	Antares 0.6°S of the Moon
07	18:50	Venus (mag.-3.9) 5.4°N of the Moon
08		α-Centaurid meteor shower maximum
08	06:30	Mars (mag. 1.3) 4.2°N of the Moon
08	21:59	Mercury (mag.-0.4) 3.2°N of the Moon
09	22:59	New Moon
10	18:53	Moon at perigee = 358,099 km
11	00:40	Saturn (mag.1.0) 1.8°N of the Moon
12	06:45	Neptune (mag.7.9) 0.7°N of the Moon
15	08:16	Jupiter (mag.-2.3) 3.2°S of the Moon
16	08:16	Uranus (mag.5.8) 3.2°S of the Moon
16	15:01	First Quarter
17	16:41	Aldebaran 9.8°S of the Moon
21	01:33	Pollux 1.6°N of the Moon
23	23:26	Regulus 3.6°S of the Moon
24	12:30	Full Moon
25–Mar.28		γ-Normid meteor shower
25	14:59	Moon at apogee = 406,312 km
28	14:00 *	Saturn (mag. 0.9) 0.2°N of Mercury (mag. -1.8)
28	14:23	Spica 1.5°S of the Moon

* These objects are close together for an extended period around this time.

After midnight 1 a.m. (DST)

Spica, Moon, E

February 2 • Shortly after midnight The Moon and Spica are due east.

Early morning 3 a.m. (DST)

Antares, 5, 6, Cat's Eyes, ESE

February 5–6 • The Moon passes Antares and the Cat's Eyes (λ and υ Sco).

Morning 6 a.m. (DST)

Nunki, 8, 9, Venus, Mars, Mercury, ESE

February 8–9 • The crescent Moon passes Venus, Mars and Mercury. Mars is not very bright (mag. 1.3).

Evening 9 p.m. (DST)

Menkar, Aldebaran, Jupiter, 15, 16, 17, Pleiades, Hamal, NW

February 15–17 • The Moon passes Jupiter and the Pleiades, surrounded by Hamal, Menkar and Aldebaran.

Evening 11 p.m. (DST)

Pollux, Castor, 20, 21, N

February 20–21 • Due north, the waxing gibbous Moon passes Pollux and Castor.

Evening 11 p.m. (DST)

Regulus, 24, Algieba, 23, NNE, NE

February 23–24 • The Full Moon passes between Regulus and Algieba.

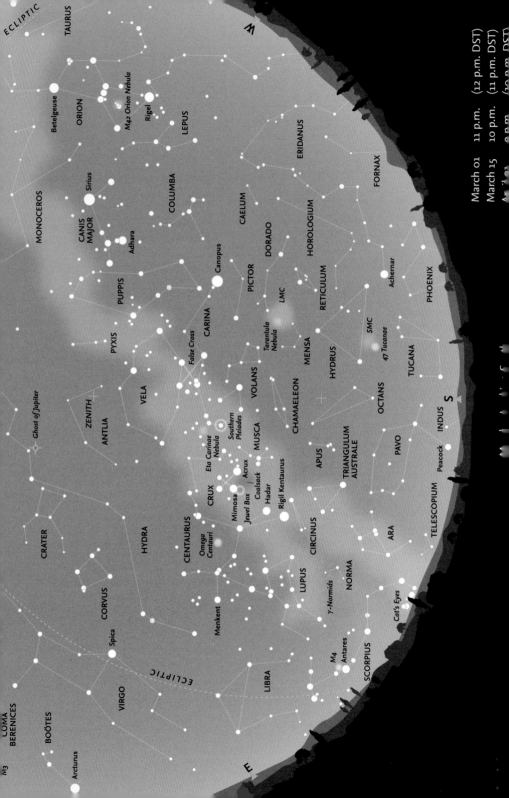

March – Looking South

The Sun crosses the celestial equator on Wednesday, March 20, at the equinox, when day and night are of almost equal length, and the southern season of autumn is considered to begin. (The hours of daylight and darkness change most rapidly around the equinoxes in March and September.)

Scorpius is beginning to become visible in the eastern sky, including the 'Cat's Eyes', the pair of stars **Shaula** and **Lesath** (λ and υ Scorpii, respectively) at the end of the 'sting'. Above Scorpius, the whole of the constellation of **Lupus** is now easy to see. The magnificent globular cluster of **Omega Centauri** is now readily visible, north-east of **Crux**. The **Coalsack** and the denser region of the Milky Way in **Carina**, together with the **Eta Carinae Nebula** and the **Southern Pleiades** are well placed for observation. The **False Cross** on the **Carina/Vela** border is now high in the sky, between the South Celestial Pole and the zenith. Brilliant **Canopus** (α Carinae) is only slightly lower towards the west, above the **Large Magellanic Cloud** (LMC) and the striking **Tarantula Nebula**. **Achernar** (α Eridani), the **Small Magellanic Cloud** (SMC) and **47 Tucanae** are considerably lower, but still clear of the horizon. **Peacock** (α Pavonis) remains low, skimming the horizon, just east of south. **Orion** is now visibly getting lower in the west, and is being followed by **Sirius** and **Canis Major**.

Meteors

The only significant meteor shower in March is the **γ-Normids**, which have a low rate, and are thus difficult to differentiate from sporadics. However, they exhibit a very sharp peak a day or so on either side of maximum on March 14–15, just before First Quarter, so conditions will be moderately favourable. The faint constellation of **Norma** rises early in the night, but most meteors are likely to be seen (away from the radiant) in the hours after midnight.

The constellation of Vela may be found in the lower part of the image, as well as the False Cross, consisting of two stars that belong to Vela, while the two stars near the bottom are part of Carina. The constellation of Pyxis is near the top (north is up).

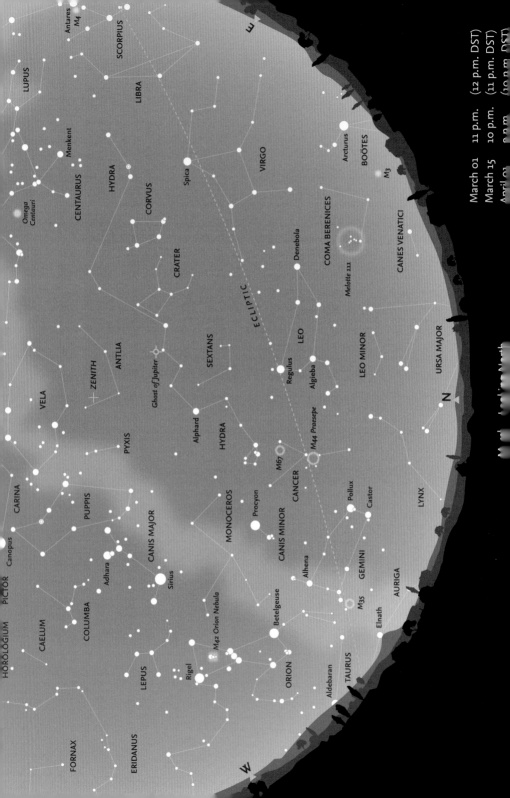

SCORPIUS
M4
Antares
LUPUS
LIBRA
Menkent
CENTAURUS
HYDRA
Omega Centauri
CORVUS
Spica
CRATER
VIRGO
Arcturus
BOÖTES
M3
COMA BERENICES
Denebola
CANES VENATICI
Melotte 111
ECLIPTIC
LEO
SEXTANS
Regulus
Algieba
LEO MINOR
ANTLIA
ZENITH
Ghost of Jupiter
URSA MAJOR
VELA
N
HYDRA
M44 Praesepe
PYXIS
Alphard
M67
CANCER
CARINA
MONOCEROS
Procyon
LYNX
PUPPIS
CANIS MINOR
Pollux
Castor
Canopus
CANIS MAJOR
Alhena
GEMINI
PICTOR
Adhara
Betelgeuse
M35
AURIGA
Sirius
HOROLOGIUM
CAELUM
COLUMBA
M42 Orion Nebula
Elnath
TAURUS
LEPUS
Rigel
ORION
Aldebaran
FORNAX
ERIDANUS

W
E

March 01 11 p.m. (12 p.m. DST)
March 15 10 p.m. (11 p.m. DST)
April 01 9 p.m. (10 p.m. DST)

March – Looking North

Almost due north is the constellation of *Leo*, with the 'backward question mark' (or 'Sickle') of bright stars forming the head of the mythological lion. *Regulus* (α Leonis) – the 'dot' of the 'question mark' or the handle of the sickle and the brightest star in Leo – lies very close to the ecliptic and is one of the few first-magnitude stars that may be occulted by the Moon, although none occur in 2024. The Moon often passes between Regulus and *Algieba* (γ Leonis). To the west lies the faint constellation of *Cancer*, with the open cluster M44, or *Praesepe*. The constellations of *Gemini* and *Orion* are now getting low in the west, but above them, both *Procyon* in *Canis Minor* and the constellation of *Canis Major* remain clear to see. The whole of *Hydra* (the largest constellation) now sprawls right across the southern and eastern skies, and the three small constellations of *Sextans*, *Crater* and *Corvus* are readily visible. The unremarkable constellation of *Antlia* is at the zenith. In the east, *Arcturus* (α Boötis) – the brightest star in the northern hemisphere of the sky – is becoming visible, and climbs higher during the night.

The Moon's phases for March 2024

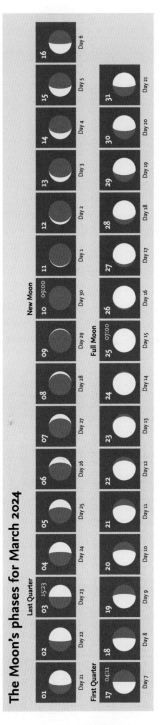

The distinctive constellation of Leo, with Regulus and 'The Sickle' on the west. Algieba (γ Leonis), north of Regulus, appearing double, is a multiple system of four stars (south is up).

March – Moon and Planets

The Moon

On March 3, at Last Quarter, the Moon is 0.4°N of *Antares*. On March 8 it passes 3.5°S of *Venus*. Later the same day it is 3.3°S of *Venus*. The next day (March 9) it is 1.5°S of *Saturn* (mag. 1.0). On March 11, a few hours after New Moon, it is 0.5°S of *Neptune* (mag. 8.0) and the next day it is 1.0°S of *Mercury* (mag. -1.3). On March 14 it is 4.0°N of *Jupiter* (mag. -2.1) and later that day 3.4°N of *Uranus* (mag. 5.8). On March 15 it is 9.9°S of *Aldebaran* in *Taurus*. On March 19, just after First Quarter, it is 1.4°S of *Pollux*. By March 22 it is 3.6°N of *Regulus*. At Full Moon (March 25) there is a penumbral lunar eclipse (visible from the USA) when the Moon may just touch the umbra. The next day the Moon is 1.4°N of *Spica*. On March 30 the Moon is 0.3°N of *Antares*.

The Planets

Mercury (mag. -0.2) reaches greatest eastern elongation on March 24. *Venus* is bright (mag. -3.8) but is closing rapidly on the Sun, and may be glimpsed early in the month. *Mars* (mag. 1.3 to 1.2) is similarly placed. *Jupiter* (mag. -2.2 to -2.1) is in *Aries* and *Saturn* (mag. 1.0 to 1.1) remains in *Aquarius*. *Uranus* (mag. 5.8) is in *Aries* and *Neptune* (mag. 8.0) in *Pisces*.

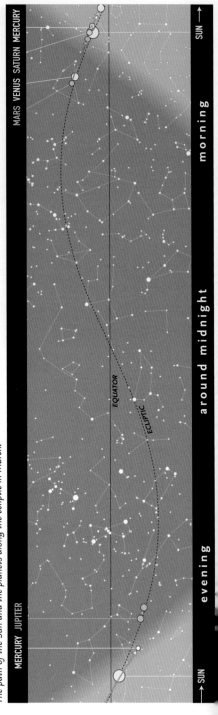

The path of the Sun and the planets along the ecliptic in March.

Calendar for March

03	08:54	Antares 0.4°S of the Moon
03	15:23	Last Quarter
03	18:01	Minor planet (3) Juno at opposition (mag. 8.7)
08	05:00	Mars (mag. 1.2) 3.5°N of the Moon
08	08:18 *	Neptune (mag. 8.0) 0.5°S of Mercury (mag. –1.5)
08	17:00	Venus (mag. –3.8) 3.3°N of the Moon
09	17:28	Saturn (mag. 1.0) 1.5°N of the Moon
10	07:04	Moon at perigee = 356,896 km (closest of the year)
10	19:26	Neptune (mag. 8.0) 0.5°N of the Moon
11	02:31	Mercury (mag. –1.3) 1.0°N of the Moon
11	09:00	New Moon
14–15		γ-Normid meteor shower maximum
14	01:02	Jupiter (mag. –2.1) 4.0°S of the Moon
14	11:35	Uranus (mag. 5.8) 3.4°S of the Moon
15	23:43	Aldebaran 9.9°N of the Moon
17	04:11	First Quarter
19	07:24	Pollux 1.4°N of the Moon
22	05:27	Regulus 3.6°S of the Moon
23	15:45	Moon at apogee = 406,294 km
24	22:34	Mercury at greatest elongation (18.7°E, mag. –0.2)
25	07:00	Full Moon
25	07:14	Penumbral lunar eclipse
26	20:23	Spica 1.4°S of the Moon
30	15:03	Antares 0.3°S of the Moon
31		Summer Time begins (BST in UK)

* These objects are close together for an extended period around this time.

After midnight 1 a.m. (DST)

March 3–4 • After midnight, the Last Quarter Moon passes Antares, in the east-southeast.

Morning 6 a.m. (DST)

March 8–9 • The crescent Moon passes Mars, Venus and Deneb Algedi (δ Cap).

Evening 8 p.m. (DST)

March 13–15 • The waxing, crescent Moon passes Jupiter and the Pleiades, with Menkar and Aldebaran closeby.

Evening 11 p.m. (DST)

March 19–22 • On March 19, the Moon is near Pollux and Castor. Three days later it passes between Regulus and Algieba.

Morning 6 a.m. (DST)

March 27 • The Moon and Spica are about thirty degrees above the western horizon.

After midnight 1 a.m. (DST)

March 31 • The Moon is close to Antares. Sabik is lower and almost due east.

April 01 11 p.m. (12 p.m. DST)
April 15 10 p.m.
May 01 9 p.m.

April – Looking South

Daylight Saving Time ends in both Australia and New Zealand on Sunday, April 7 with the arrival of autumn. **Crux** is now high in the south, with the two brightest stars of **Centaurus** (α and β Centauri, **Rigil Kentaurus** and **Hadar**, respectively) to its east. The magnificent globular cluster, **Omega Centauri**, is readily visible high in the sky. West of Crux, both the **Southern Pleiades** and the **Eta Carinae Nebula** are clearly seen, two-thirds of the way towards the zenith. Farther west, the **False Cross** is beginning to decline towards the horizon. **Canopus** (α Carinae) is even lower, and **Orion** has now disappeared below the horizon. **Canis Major** and brilliant **Sirius** are also descending in the west. **Achernar** (α Eridani) is skimming the southern horizon, but **Peacock** (α Pavonis) is now slightly higher and more easily visible. Although the **LMC** is roughly as high as the South Celestial Pole, the **SMC** and **47 Tucanae** are rather low (but still visible) in the south. In the east, the whole of **Scorpius** is now well clear of the horizon with the inconspicuous constellation of **Libra** preceding it along the ecliptic. The dense regions of the Milky Way in **Sagittarius** become visible later in the night.

Meteors

Two meteor showers, in particular, occur in April. The **π-Puppid** shower begins on April 15, but conditions are very unfavourable in 2024 with shower maximum on April 23–24, when the Moon is Full. The hourly rate is variable but the meteors tend to be faint. The parent body is the comet 26P/Grigg-Skjellerup. A second, more prolific, shower, the **η-Aquariids**, begins on April 19, when the Moon is waxing gibbous, and continues into May.

Omega Centauri (NGC 5139) is the largest and finest globular cluster in the sky (and in the Milky Way galaxy). It is believed to contain 10 million stars and differs in chemical composition and nature so greatly from other globulars that it may be the core of a disrupted dwarf galaxy, captured by the far more massive Galaxy.

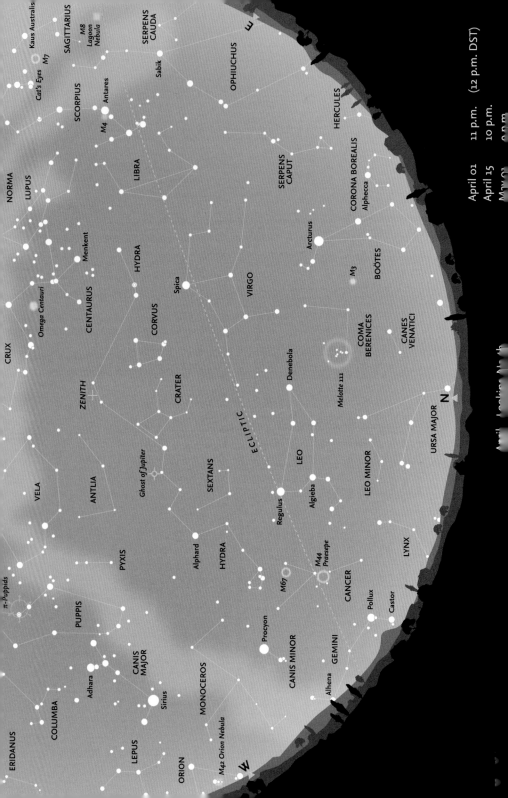

April Looking North

April 01 11 p.m. (12 p.m. DST)
April 15 10 p.m.
May 01 9 p.m.

April – Looking North

Leo is the most prominent constellation in the northern sky in April. **Gemini**, with **Castor** and **Pollux**, is low on the horizon in the west, and **Cancer** lies between the two constellations. To the east of Leo, the whole of **Virgo**, with **Spica** (α Virginis) its brightest star, is clearly visible, with the constellation of **Libra** farther east along the ecliptic. Above Leo and Virgo, the complete length of **Hydra** is visible, with **Alphard** (α Hydrae) forming a prominent triangle with **Regulus** and **Procyon** in **Canis Minor**. High in the sky, the small constellations of **Sextans** and **Crater**, together with the rather brighter **Corvus** lie between Leo, Virgo and Hydra.

Boötes and **Arcturus** are prominent in the northeastern sky, together with the globular cluster M3 in **Canes Venatici**. The circlet of **Corona Borealis** is close to the horizon. Between Leo and Boötes lies the constellation of **Coma Berenices**, notable for being the location of the open cluster Melotte 111 (this is sometimes called the Coma Cluster and confused with the Coma Cluster of galaxies (Abell 1656) east of **Denebola** in **Leo**). There are about 1,000 galaxies in Abell 1656, shown on the chart on page 61, and which is located near the North Galactic

A very large, and frequently ignored, open star cluster, Melotte 111, also known as the Coma Cluster, is readily visible in the northen sky during April and May (south is up).

Pole, where we are looking out of the plane of the Galaxy and are thus able to see deep into space. Only about ten of the brightest galaxies in the Coma Cluster are visible with the largest amateur telescopes.

The Moon's phases for April 2024

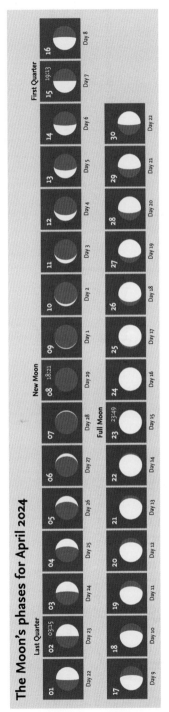

April – Moon and Planets

The Moon

On April 8, at New Moon, there is a total solar eclipse, with the track covering Mexico, the eastern states of the USA and eastern Canada (see pages 20 and 21). The Moon then passes the *Pleiades* and by April 12 is 10°N of *Aldebaran* in *Taurus*. It is 1.5°S of *Pollux* by April 15 and 3.5°N of *Regulus*, between it and *Algieba* on April 18. Before Full Moon on April 23, it is 1.4°N of *Spica* in *Virgo* and 0.3°N of *Antares* by April 26.

The planets

Mercury is too close to the Sun to be visible this month. *Venus* is similarly placed. *Mars* is moving towards the Sun, but may be glimpsed in the morning sky early in the month. *Jupiter* (mag. -2.0) is in *Aries*, crossing into *Taurus* (mag. 1.1 to 1.2) is moving slowly in *Aquarius*. *Uranus* (mag. 5.8) remains in *Aries* and *Neptune* (mag. 8.0 to 7.9) in *Pisces*.

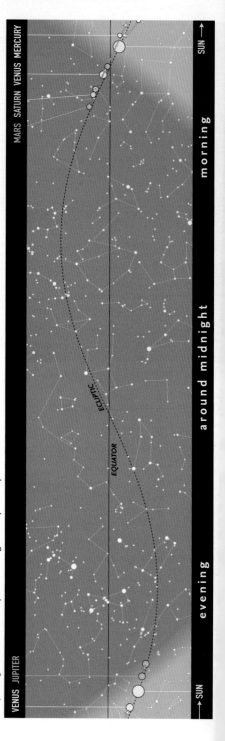

The path of the Sun and the planets along the ecliptic in April.

Calendar for April

Evening 6:15 p.m.

April 11 • After sunset, the crescent Moon and Jupiter are about eight degrees above the horizon. Menkar, Aldebaran and Elnath are all nearby. The Pleiades will not be easy to spot.

Midnight

April 18/19 • At midnight, the Moon is between Regulus and Algieba.

Evening 6 p.m.

April 15 • The Moon is near First Quarter, and almost due north, when it forms a nice triangle with Pollux and Castor.

Early morning 4 a.m.

April 23–24 • The Moon passes Spica in the western sky.

Morning 6 a.m.

April 27 • The Moon is close to Antares, high in the west. Sabik and the Cat's Eyes are nearby.

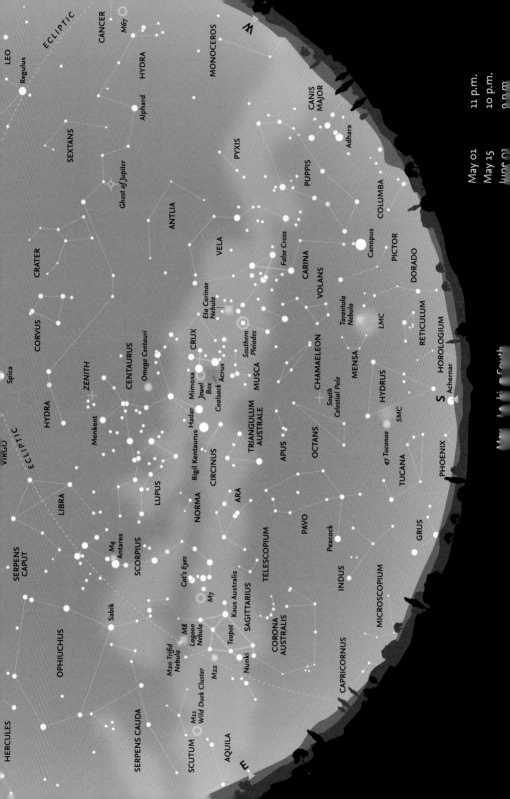

May 01 11 p.m.
May 15 10 p.m.
June 01 9 p.m.

May – Looking South

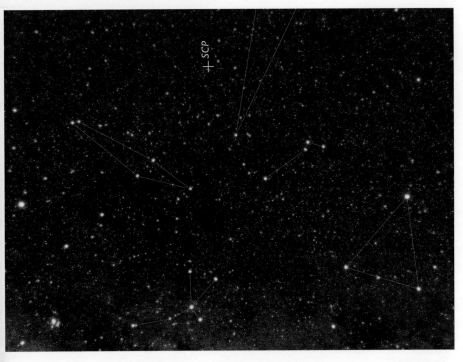

In the west, **Canis Major** has set below the horizon, and **Canopus** (α Carinae) and **Puppis** are getting rather low. The whole of **Sagittarius** is now clearly seen in the east, with **Corona Australis** beneath it and **Scorpius** higher above. **Centaurus** is fully seen high in the south, with **Crux**, the **Eta Carinae Nebula**, the **Southern Pleiades** and the **False Cross** with **Vela** along the Milky Way to the west. In the south, **Achernar** (α Eridani) is skimming the southern horizon and the **Small Magellanic Cloud** (SMC) is beginning to rise higher in the sky, unlike the **Large Magellanic Cloud** (LMC) which is now much lower. **Pavo** and **Peacock** (α Pavonis) are now much higher and even the faint constellations of **Tucana** and **Indus** are visible between Pavo and the southwestern horizon.

Meteors

The **η-Aquariids** are one of the two meteor showers associated with Comet 1P/Halley (the other being the **Orionids**, in October). The radiant is near the celestial equator, close to the 'Water Jar' in **Aquarius**, well below the horizon. However, meteors may still be seen in the eastern sky even when the radiant is below the horizon. There is a radiant map for the η-Aquariids on page 30. Their maximum in 2024, on May 6, occurs just before New Moon, so conditions are favourable. Maximum hourly rate is about 50 per hour and a large proportion (about 25 per cent) of the meteors leave persistent trains.

Some faint constellations around the South Celestial Pole (SCP), Below the Pole, a part of the constellation of Octans is visible. Then, a little lower, Apus and farther down, Triangulum Australe. To the left is Musca and just above the centre of the image is Chamaeleon. The bright star near the top edge of the image is Miaplacidus, in the constellation of Carina.

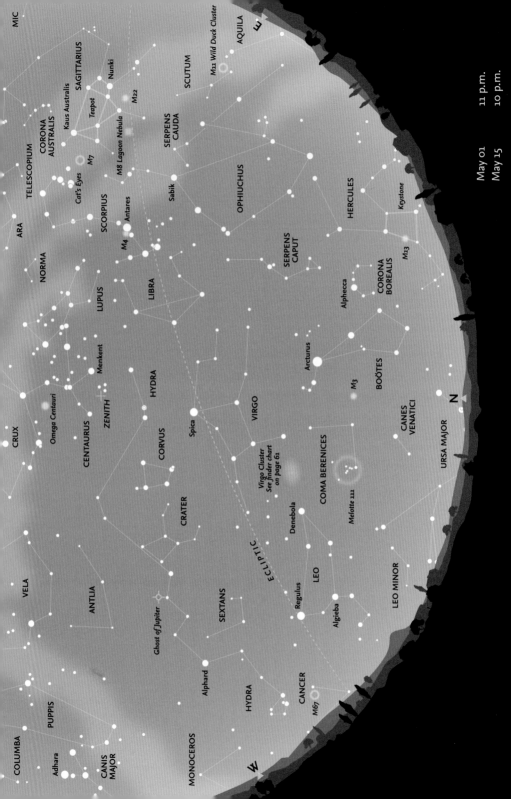

May – Looking North

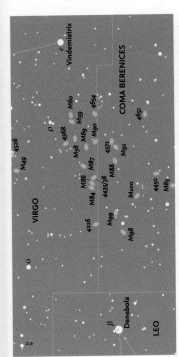

Boötes is almost due north, with brilliant, slightly orange-coloured *Arcturus* extremely prominent. The distinctive circlet of *Corona Borealis* is clearly visible to its east. The brightest star (α Coronae Borealis) is known as *Alphecca*. *Hercules* is rising in the east and becomes clearly visible later in the night. To the west of Boötes is the inconspicuous constellation of *Coma Berenices*, with the cluster *Melote 111* (see page 55) and, above it, the Virgo Cluster of galaxies (see here).

The large constellation of *Ophiuchus* (which actually crosses the ecliptic, and is thus the 'thirteenth' zodiacal constellation) is climbing into the eastern sky. Before the constellation boundaries were formally adopted by the International Astronomical Union in 1930, the southern region of Ophiuchus was regarded as forming part of the constellation of *Scorpius*, which had been part of the zodiac since antiquity.

Early in the night, the constellation of *Virgo*, with *Spica* (α Virginis), lies due north, with the rather faint constellation of *Libra* to its east. Farther along the ecliptic are Scorpius and brilliant, reddish *Antares* (α Scorpii). In the west, the constellation of *Leo* is

A finder chart for some of the brightest galaxies in the Virgo Cluster (see page 60). All stars brighter than magnitude 8.5 are shown (south is up).

readily visible now, and both *Regulus* and *Denebola* (α and β Leonis, respectively) are prominent.

Virgo contains the nearest large cluster of galaxies, which is the centre of the Local Supercluster, of which the Milky Way galaxy forms part. The Virgo Cluster contains some 2,000 galaxies, the brightest of which are visible in amateur telescopes.

The Moon's phases for May 2024

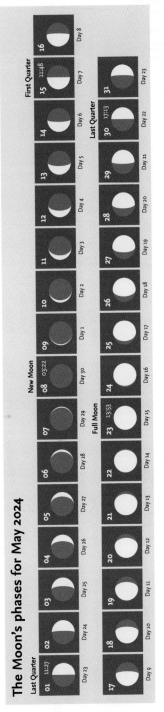

May – Moon and Planets

The Moon

On May 3, the Moon is 0.8°S of **Saturn** (mag. 1.2) and the next day is 0.3°S of much fainter **Neptune** (mag. 7.9). By May 5 it is 0.2°N of **Mars** (mag. 1.0). On May 6 it is 3.8°N of **Mercury** (mag. 0.6) and the next day 3.5°N of much brighter **Venus** (mag. -3.9). At New Moon on May 8, it is 3.6°N of faint **Uranus** (mag. 5.8) and a few hour later 4.3°N of **Jupiter** (mag. -2.0). On May 9 it is 9.9°N of **Aldebaran** in **Taurus**. On May 12 the Moon is 1.6°S of **Pollux**. At First Quarter on May 15, it is 3.5°N of **Regulus**. By May 20, the Moon is 1.4°N of **Spica** in **Virgo**. On May 24, the Moon (just past Full) is 0.4°N of **Antares**. By May 31, the Moon is 0.4°S of **Saturn**.

The planets

Mercury (mag. 0.4) reaches greatest elongation west in the evening sky on May 9. By May 31 (at mag. -0.7) it is 1.4°S of **Uranus** (mag. 5.8). **Venus** passes conjunction with the Sun, so is invisible this month. **Mars** is moving towards the Sun, so is also invisible. **Jupiter** (mag. -2.0), now in **Taurus**, is moving slowly east in **Aquarius**. **Uranus** (mag. 5.8) remains in **Aries** and **Neptune** (mag. 7.9) in **Pisces**.

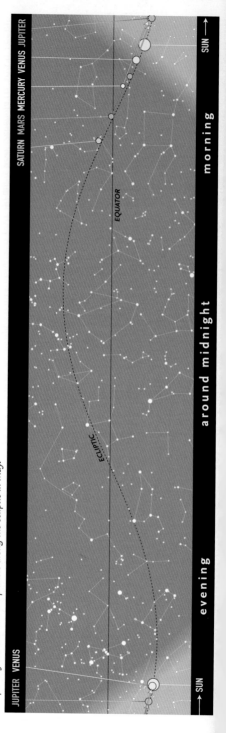

The path of the Sun and the planets along the ecliptic in May.

Calendar for May

01	11:27	Last Quarter
03	22:32	Saturn (mag. 1.2) 0.8°N of the Moon
04	18:55	Neptune (mag. 7.9) 0.3°N of the Moon
05	02:25	Mars (mag. 1.0) 0.2°S of the Moon
05	22:04	Moon at perigee = 363,163 km
06		η-Aquariid meteor shower maximum
06	08:25	Mercury (mag. 0.6) 3.8°S of the Moon
07	16:03	Venus (mag. -3.9) 3.5°S of the Moon
08	03:22	New Moon
08	12:51	Uranus (mag. 5.8) 3.6°S of the Moon
08	18:14	Jupiter (mag. -2.0) 4.3°S of the Moon
09	18:54	Aldebaran 9.9°S of the Moon
09	21:29	Mercury at greatest elongation (26.4°W, mag. 0.4)
12	22:54	Pollux 1.6°N of the Moon
15	11:48	First Quarter
15	19:24	Regulus 3.5°S of the Moon
17	18:59	Moon at apogee = 404,640 km
19	15:06	Minor planet (2) Pallas at opposition (mag. 9.0)
20	10:03	Spica 1.4°S of the Moon
23	13:53	Full Moon
24	03:10	Antares 0.4°S of the Moon
30	17:13	Last Quarter
31	01:00 *	Uranus (mag. 5.8) 1.4°N of Mercury (mag. -0.7)
31	08:09	Saturn (mag. 1.2) 0.4°N of the Moon. An occultation of Saturn is visible from Patagonia

* These objects are close together for an extended period around this time.

Morning 6 a.m.

May 4–6 • The crescent Moon passes Saturn, Mars and Mercury. Saturn and Mars are equally bright (mag. 1.1). Mercury is just slightly brighter (mag. 0.9).

Evening 7 p.m.

May 12–13 • In the northwest, the Moon passes the Twin Stars, Pollux and Castor. Alhena is farther west.

Evening 7 p.m.

May 20 • The Moon is close to Spica. Arcturus is about thirty degrees closer to the horizon, and farther north.

Evening 7 p.m.

May 23–24 • In the eastern sky, the Full Moon passes Antares, flanked by Sabik and the Cat's Eyes.

June – Looking South

Both **Canopus** (α Carinae) and **Achernar** (α Eridani) are skimming the southern horizon. Although the whole of **Carina** is visible, all of **Eridanus** (except **Achernar**) is hidden below the horizon. The **Large Magellanic Cloud** (LMC) is low, although the **Small Magellanic Cloud** (SMC), the globular cluster, **47 Tucanae** and **Hydrus** are now rather higher. **Alphard** (α Hydrae) is on the horizon, and the constellation of **Sextans** is becoming low. However, the remainder of the long constellation of **Hydra** is clearly seen as are the two constellations of **Crater** and **Corvus** to its north. The **False Cross** between Carina and **Vela** is beginning to descend in the west, but Vela itself is clearly visible. The whole of both **Crux** and **Centaurus** are clearly seen, as are the magnificent globular cluster, **Omega Centauri,** and the constellation of **Lupus,** closer to the zenith. The constellation of **Triangulum Australe** is on the meridian, roughly halfway between the South Celestial Pole and the zenith. Both **Scorpius,** with brilliant, red **Antares** (α Scorpii) and **Sagittarius** are high overhead, with the faint constellation of **Corona Australis** visible below them. The whole of **Capricornus** is visible, and the constellation of **Grus** has now risen above the horizon, with the faint constellation of **Indus** between it and **Pavo.** To the east of Grus is **Piscis Austrinus,** although brilliant **Fomalhaut** (α Piscis Austrini) is only just clear of the horizon, and becomes clearly visible only later in the night and later in the month.

The distinctive shape of the zodiacal constellation of Scorpius. The red supergiant star, Antares is close to the zenith in June. The bright spot near the left side of the image is the open cluster M7, also known as Ptolomy's Cluster (north is up).

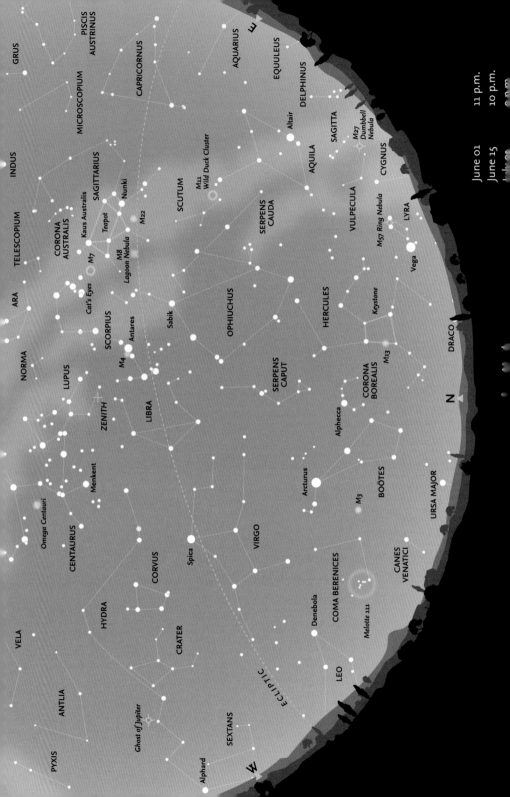

June – Looking North

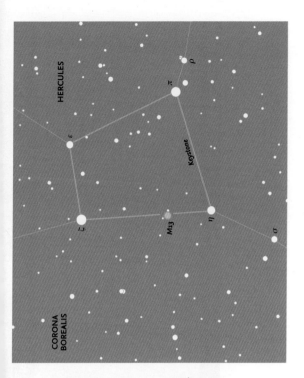

Vega in **Lyra** is just above the northeastern horizon. Closer to the meridian, the whole of **Hercules** is visible including the **'Keystone'** and **M13**, widely regarded as the finest globular cluster in the northern hemisphere. The small constellation of **Corona Borealis** is almost due north. To the west of the meridian is **Boötes** and **Arcturus** (α Boötis). Much of **Leo** is now below the western horizon, but **Denebola** (β Leonis) is still visible. Higher in the sky, the whole of **Virgo** is clearly visible and, still higher, not far from the zenith is the constellation of **Libra**. To its east is **Scorpius** and reddish **Antares**. Farther along the ecliptic, both the constellations of **Sagittarius** and **Capricornus** are completely visible. Between Hercules and Sagittarius is the large constellation of **Ophiuchus** and, to its east, **Aquila** and **Altair** (α Aquilae), one of the stars of the (northern) Summer Triangle. Another of the three stars, **Vega** in **Lyra**, is skimming the northern horizon.

Finder chart for M13, the finest globular cluster in the northern sky. All stars down to magnitude 7.5 are shown (south is up).

The Moon's phases for June 2024

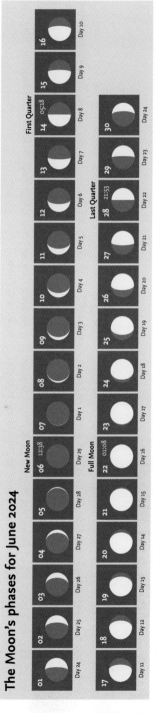

June – Moon and Planets

The Moon

On June 1, the Moon passes extremely close and to the south of *Neptune*, but there is no occultation. The next day it is 2.4°N of *Mars*. On June 5, the day before New Moon, it passes 3.7°N of *Uranus* (mag. 5.8) and later that day 4.7°N of *Jupiter* (mag. -2.0). Later again, that same day, it is 4.7°N of *Mercury* (mag. -1.2). It is 9.9°N of *Aldebaran* on June 6 (at New Moon). By June 9 it is 1.7°S of *Pollux* and by June 12, 3.3°N of *Regulus* in *Leo*. On June 16 it is 1.2°N of *Antares*. By June 20, the Moon is 0.3°N of *Spica*. By June 27, the Moon is 0.1°N of *Saturn* and, the next day (June 28) it is 0.3°N of *Neptune* (mag. 7.9).

The planets

Mercury moves from the morning to the evening sky and is mag. -1.2 and 4.7°S of the Moon on June 5 (one day before New Moon). *Venus* is very close to the Sun in *Gemini*. Mars (mag. 1.0) moves from *Pisces* into *Aries*. Jupiter (mag. -2.0) is in *Taurus*, 4.7°S of the Moon on June 5 (one day before New Moon). *Saturn* (mag. 1.1) is moving slowly east in *Aquarius*. *Uranus* (mag. 5.8) is now in *Taurus* and *Neptune* (mag. 7.9) remains in *Pisces*.

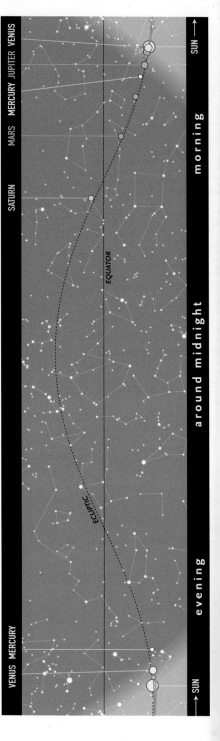

The path of the Sun and the planets along the ecliptic in June.

Calendar for June

01	02:54	Neptune (mag.7.9) 0.0°N of the Moon
02	07:16	Moon at perigee = 368,102 km
02	23:37	Mars (mag.1.1) 2.4°S of the Moon
04	10:00 *	Jupiter (mag.-2.0) 0.1°N of Mercury (mag.-1.1)
05	00:37	Uranus (mag.5.8) 3.7°S of the Moon
05	14:25	Jupiter (mag.-2.0) 4.7°S of the Moon
05	18:28	Mercury (mag.-1.2) 4.7°S of the Moon
06	04:21	Aldebaran 9.9°S of the Moon
06	12:38	New Moon
09	08:00	Pollux 1.7°N of the Moon
12	03:41	Regulus 3.3°S of the Moon
14	05:18	First Quarter
14	13:25	Moon at apogee = 404,077 km
16	18:11	Spica 1.2°S of the Moon
20	11:11	Antares 0.3°S of the Moon
22	01:08	Full Moon
27	11:30	Moon at perigee = 369,286 km
27	15:00	Saturn (mag.1.1) 0.1°S of the Moon
		An occultation of Saturn is visible from eastern Australia
28	08:56	Neptune (mag.7.9) 0.3°S of the Moon
28	21:53	Last Quarter

* These objects are close together for an extended period around this time.

Morning 5 a.m.

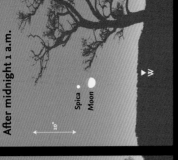

June 3 • The Moon and Mars are side-by-side in the east-northeast. Menkar is lower and farther east.

Evening 5:30 p.m.

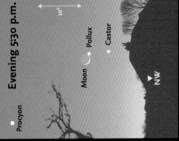

June 9 • The crescent Moon is close to Pollux and Castor. Procyon is much higher and farther west.

After midnight 1 a.m.

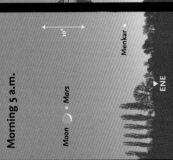

June 17 • The Moon is in the company of Spica, almost due west.

Evening 8 p.m.

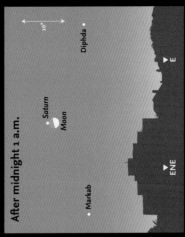

June 20 • High in the east, the Moon and Antares are close together, with Sabik (η Oph), the Cat's Eyes (λ and υ Sco) and Kaus Australis (ε Sgr) nearby.

After midnight 1 a.m.

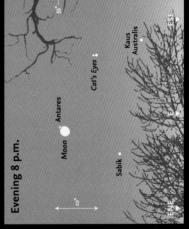

June 28 • The Moon with Saturn, close together in the eastern sky, flanked by Markab (α Peg) and Diphda (β Cet).

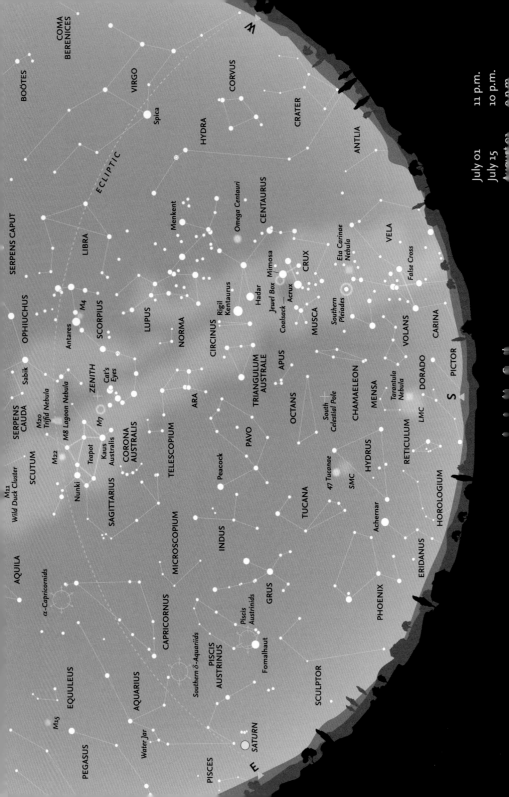

July – Looking South

Part of the central Milky Way in the constellations of Norma and Scorpius, showing the dark clouds of obscuring dust (north is up).

Although the *Large Magellanic Cloud* (LMC) is almost due south, it is very low. Slightly farther west, the *False Cross* is nearing the horizon. Some of *Hydra* remains visible, but the constellation of *Crater* is becoming very low. *Corvus* is still easy to see. The zodiacal constellation of *Virgo* will soon be disappearing in the west. *Crux*, *Centaurus* and *Lupus* are still clearly seen, high in the sky, as is *Scorpius*, the tail of which is near the zenith. *Achernar* (α Eridani), *Hydrus* and the *Small Magellanic Cloud* (SMC) are now higher above the horizon and easier to observe. The whole of the constellation of *Phoenix* is also now clear of the horizon. Above it are *Tucana* and, halfway to the zenith, the constellation of *Pavo*. *Grus* and *Pisces Austrinus* (with brilliant *Fomalhaut*) are now fully visible. Higher in the sky are the zodiacal constellations of *Capricornus* and *Aquarius*, and even the westernmost portion of *Pisces* is rising above the horizon.

Meteors

July brings increasing meteor activity, mainly because there are several minor radiants active in the constellations of *Capricornus* and *Aquarius*. The first shower, the *α-Capricornids*, active from July 3 to August 15 (peaking July 30), does often produce very bright fireballs. The maximum rate, however, is only about 5 per hour. The parent body is Comet 169P/ NEAT. The most prominent shower is probably that of the *Southern δ-Aquariids*, which are active from around July 12 to August 23, also with a peak on July 30, although even then the hourly rate is unlikely to reach 25 meteors per hour. In this case, the parent body is possibly Comet 96P/Machholz. This year, both shower maxima occur when the Moon is a waning crescent just after Last Quarter, so conditions are not very favourable. The *Piscis Austrinids* begin on July 15 and continue until August 10. Maximum is on July 28, but the rate is only about 5 per hour. The *Perseids* begin on July 17 and peak on August 12–13.

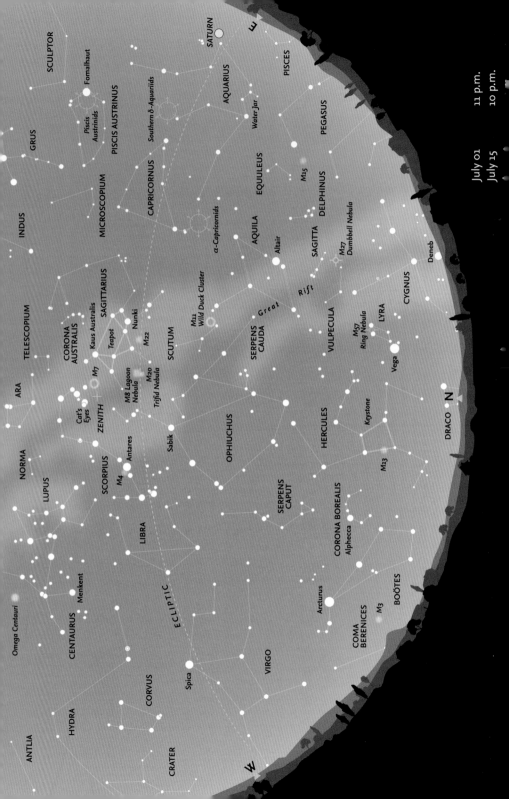

July – Looking North

The constellations of *Hercules* and *Lyra* are on either side of the meridian and both are clearly visible well above the horizon. To the east, *Deneb* (α Cygni) is skimming the horizon, but nearly all of the rest of the constellation is easily seen as is *Aquila* with *Altair* (α Aquilae). Between *Cygnus* and Aquila lies the small constellation of *Sagitta*, with *M27* (the Dumbbell Nebula, a planetary nebula). Even farther east, the whole extent of both the zodiacal constellations of *Aquarius* and *Capricornus* is visible, farther along the *Great Rift* is the small constellation of *Scutum*, with *M11*, the Wild Duck Cluster. To its east is the tiny, but distinctive constellation of *Delphinus*. Still farther along the Great Rift lies the centre of the Milky Way Galaxy (in *Sagittarius*) and, near it, two emission nebulae: *M8* (the Lagoon Nebula) and *M20* (the Trifid Nebula). In the western sky, the constellation of *Boötes* and *Arcturus* (α Boötis) are beginning to approach the horizon, but *Corona Borealis* is still clearly seen. Even farther west, the whole of *Virgo* is visible, with *Libra* above it. The large constellation of *Ophiuchus* and the two halves of *Serpens* lie between Hercules and the zenith. *Scorpius* is draped around the actual zenith with Sagittarius to its east.

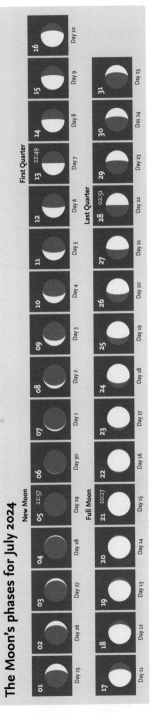

The constellation of Virgo. Spica (α Virginis) is the bright blue star near the top of the image, with Mars to its northeast (south is up).

The Moon's phases for July 2024

New Moon

01	02	03	04	05 22:57	06	07	08	09	10	11	12
Day 25	Day 26	Day 27	Day 28	Day 29	Day 30	Day 1	Day 2	Day 3	Day 4	Day 5	Day 6

First Quarter

13 22:49	14	15	16
Day 7	Day 8	Day 9	Day 10

Full Moon

17	18	19	20	21 10:17	22	23	24	25	26	27
Day 11	Day 12	Day 13	Day 14	Day 15	Day 16	Day 17	Day 18	Day 19	Day 20	Day 21

Last Quarter

28 02:51	29	30	31
Day 22	Day 23	Day 24	Day 25

July – Moon and Planets

The Moon

On July 1, the Moon is 4.1°N of **Mars** (mag.1.0). The next day it is 4.0°N of **Uranus** (mag.5.8). By July 3 it is 5.0°N of **Jupiter** (mag.-2.0) and, later, 9.9°N of **Aldebaran**. On July 6 the Moon is 3.9°N of **Venus** (mag.-3.9) and later 1.8°S of **Pollux** in **Gemini**. The next day the Moon is 3.2°N of **Mercury** (mag.-0.3). By July 9 it passes 3.0°N of **Regulus**, between it and **Algieba**. On July 14, one day after First Quarter, it is 0.9°N of **Spica**. On July 17 the Moon is 0.2°N of **Antares** in **Scorpius**. By July 24 the waning gibbous Moon is 0.4°N of **Saturn** (mag.0.9) and the next day 0.6°N of **Neptune** (mag.7.8). On July 29, one day after Last Quarter, the waning crescent Moon is 4.2°N of **Uranus** (mag.5.8). By July 30 it passes 10.1°N of **Aldebaran**, 5.0°N of **Mars** (mag.0.9) and 5.4°N of **Jupiter** (mag.-2.1).

The planets

Mercury is moving eastwards past the Sun, and comes to eastern elongation on July 22 at mag.0.3. **Venus** is bright (mag.-3.9) in the evening sky. **Mars** (mag.1.0 to 0.9) is in **Aries**, moving into **Taurus** at the end of the month. **Jupiter** (mag.-2.0 to -2.1) is moving slowly eastwards in **Taurus**. **Saturn** (mag.1.0 to 0.9) is in **Aquarius** and begins retrograde motion on July 4. **Uranus** (mag.5.8) is in **Taurus** and **Neptune** (mag.7.9) remains in **Pisces**.

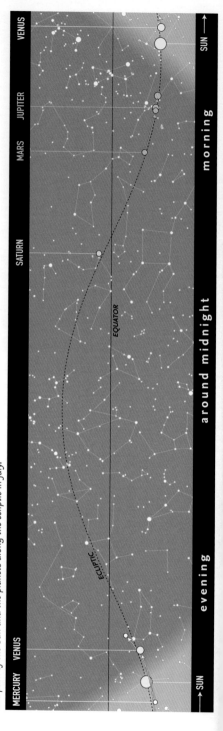

The path of the Sun and the planets along the ecliptic in July.

Calendar for July

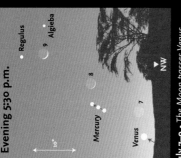

Morning 6:30 a.m.

July 2–4 • In the northeast, the crescent Moon passes Mars, the Pleiades, Jupiter and Aldebaran.

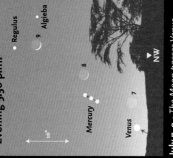

Evening 6 p.m.

July 14 • Very high and due north, the Moon and Spica are side by side.

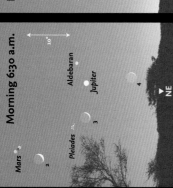

Evening 5:30 p.m.

July 7–9 • The Moon passes Venus, Mercury, Regulus and Algieba. Venus is bright but very close to the horizon.

Evening 6 p.m.

July 17–18 • The Moon passes Antares, with the Cat's Eyes and Sabik nearby.

Morning 5 a.m.

July 30–31 • In the northeast, the Moon passes the Pleiades and Aldebaran.

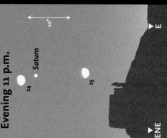

Evening 11 p.m.

July 24–25 • The Moon moves almost vertically, when it passes Saturn.

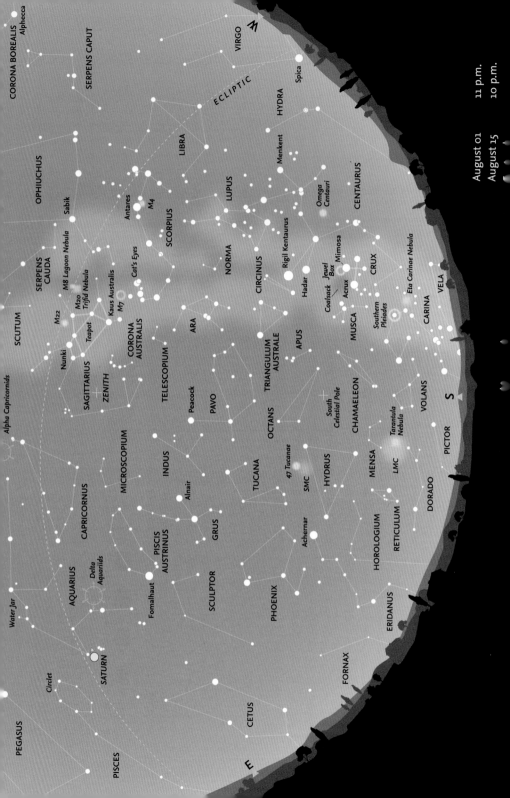

August – Looking South

Three inconspicuous constellations: *Volans*, *Chamaeleon* and *Octans* are on the meridian, with *Pavo* higher towards the zenith. Much of *Carina* is below the horizon, although the *Eta Carinae Nebula* and the *Southern Pleiades* are still visible. The *Large Magellanic Cloud* (LMC) and the faint constellation of *Mensa* are slightly higher in the sky. *Crux* is now lower, but the whole of *Centaurus* and *Lupus* remains visible. Much of *Virgo* has set in the west and *Libra* is following it down towards the horizon. *Scorpius* and *Sagittarius* are still visible high in the sky. *Achernar*, the *Small Magellanic Cloud* (SMC) and *Hydrus* are now well clear of the horizon, but below them are more small, inconspicuous constellations: *Dorado*, *Reticulum* and *Horlogium*. More of *Eridanus* is visible, together with parts of *Pictor* and *Fornax*. Much of *Cetus* has risen and the whole of the western arm of *Pisces* is now clearly seen. *Sculptor*, *Grus* and *Piscis Austrinus* lie halfway between the eastern horizon and the zenith, with faint *Microscopium* closer to the actual zenith.

Meteors

The *Piscis Austrinid* shower continues until about August 10, after maximum on July 28. The *Southern δ-Aquariids* reach maximum on July 30 to August 1, but are unlikely to exhibit more than about 25 meteors per hour. There are several minor southern showers active during the month: the *Northern δ-Aquariids* (maximum August 13), the *Southern* and *Northern ι-Aquariids* (maxima August 4 and August 19, respectively), but in all cases the rates are very low, just single figures per hour. The *α-Aurigid* shower begins on August 28, and is a short shower, lasting until September 5, reaching maximum in 2024 on September 1.

The Large Magellanic Cloud (LMC) lies mostly in the constellation of Dorado, partly extending into neighbouring Mensa. It contains many globular and open clusters as well as gaseous nebulae, such as the giant Tarantula Nebula.

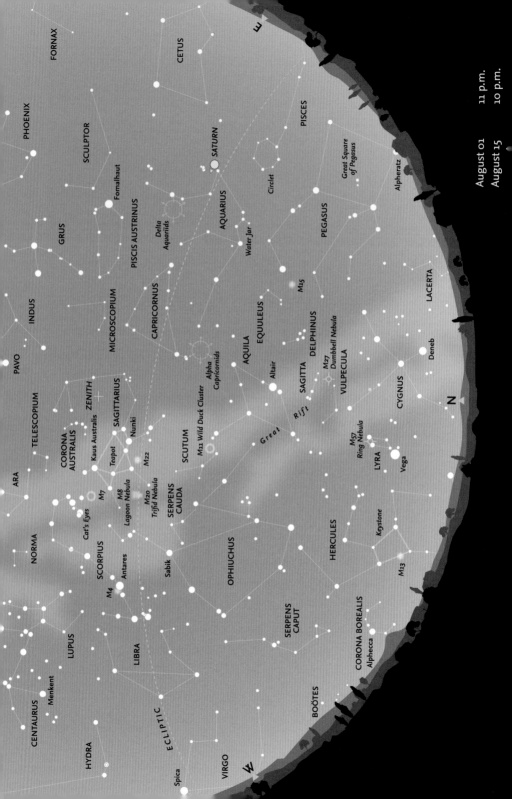

August 01 11 p.m.
August 15 10 p.m.

August – Looking North

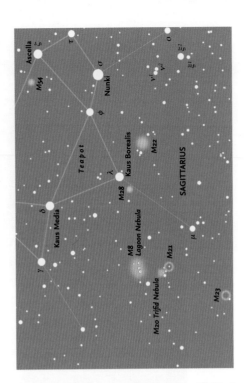

Cygnus, with brilliant *Deneb* (α Cygni), is now prominent just to the east of the meridian. The other two stars of the (northern) Summer Triangle, *Vega* in **Lyra** and *Altair* in **Aquila** are also unmistakeable in the sky. *Hercules,* however, is beginning to descend towards the northwestern horizon. Above it, the sprawling constellation of **Ophiuchus** is readily seen. The Great Square of **Pegasus** is now visible in the east, although *Alpheratz* (α Andromedae) is low on the horizon. The western side of *Pisces, Aquarius* and **Capricornus** are fully visible along the ecliptic. **Sagittarius** contains many gaseous nebulae, like **M8** (the Lagoon Nebula) and **M20** (the Trifid Nebula) and several globular clusters such as **M22.** The constellation is at the zenith, with Scorpius to the west.

A finder chart for the gaseous nebulae M8 (the Lagoon Nebula), M20 (the Trifid Nebula) and the globular cluster M22, all in Sagittarius. Clusters M21, M23 (open) and M28 (globular) are faint. The chart shows all stars brighter than magnitude 7.5 (south is up).

The Moon's phases for August 2024

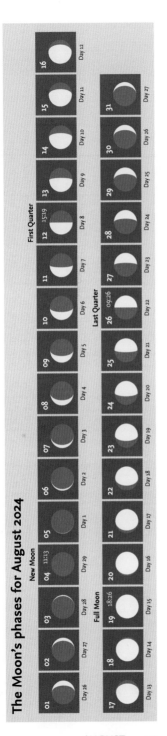

August – Moon and Planets

The Moon

On August 2, the Moon is 1.8°S of **Pollux**. By August 5 it is 2.9°N of **Regulus** in **Leo**. Later the same day it is 1.7°N of **Venus** (mag. -3.8). On August 6 the Moon is 7.5°N of **Mercury** and close to **Venus**. By August 10 the waxing crescent Moon is 0.7°N of **Spica**. On August 14, the Moon occults **Antares,** but this is visible only over the Pacific Ocean. By August 21, the Moon is 0.5°N of **Saturn** (mag. 0.7) and later that day is 0.7°N of **Neptune** (at mag. 7.8). By August 26 the Moon is 4.4°N of **Uranus** (mag. 5.7) and, later, 10.3°N of **Aldebaran.** On August 28, the Moon passes 5.3°N of **Mars** and on August 30, 1.7°S of **Pollux.**

The Planets

Mercury rapidly moves west and declines from mag. 0.9 to 2.2 before brightening at the end of the month to mag. 0.8. **Venus** is close by early in the month. **Mars** (mag. 0.8) is moving east in **Taurus. Jupiter** is also moving slowly east in **Taurus. Saturn** (mag. 0.7) continues retrograde motion throughout August. **Uranus** (mag. 5.7) is still in **Taurus** and **Neptune** (mag. 7.8) remains in **Pisces.** Minor planet(7) Iris (mag. 8.1) is at opposition on August 6 (see the maps on page 27).

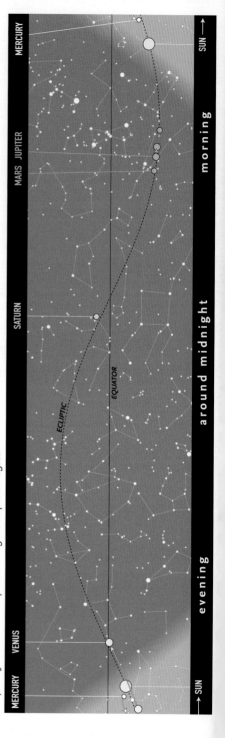

The path of the Sun and the planets along the ecliptic in August.

Calendar for August

02	23:35	Pollux 1.8°N of the Moon
04	11:13	New Moon
05	19:34	Regulus 2.9°S of the Moon
05	22:03	Venus (mag. -3.8) 1.7°S of the Moon
06	00:02	Mercury (mag. 1.6) 7.5°S of the Moon
06	15:00 *	Venus (mag. -3.8) 5.9°N of Mercury (mag. 1.6)
06	19:40	Minor planet (7) Iris at opposition (mag. 8.1)
09	01:31	Moon at apogee = 405,297 km
10	10:17	Spica 0.7°S of the Moon
12–13		Perseid meteor shower maximum
12	15:19	First Quarter
14	05:17	Antares 0.0°N of the Moon
		There is an occultation of Antares, visible only over the Pacific Ocean
19	18:26	Full Moon
21	03:02	Saturn (mag. 0.7) 0.5°N of the Moon
		An occultation of Saturn is visible from northern South America
21	05:02	Moon at perigee = 360,196 km
21	22:21	Neptune (mag. 7.8) 0.7°S of the Moon
26	00:01	Uranus (mag. 5.7) 4.4°S of the Moon
26	09:26	Last Quarter
26	23:29	Aldebaran 10.3°S of the Moon
27	12:43	Jupiter (mag. -2.3) 5.7°S of the Moon
28–Sep.05		α-Aurigid meteor shower
28	00:22	Mars (mag. 0.8) 5.3°S of the Moon
30	05:25	Pollux 1.7°N of the Moon

* These objects are close together for an extended ...

Evening 6 p.m. — labels: Denebola, Moon, Mercury, Venus, Regulus, Algieba; W·NW

August 6 • The Moon is close to Venus, Regulus and Mercury, with Algieba and Denebola close by.

Evening 9 p.m. — labels: Spica, Moon; W

August 10 • Due west, the Moon and Spica are close together.

Evening 11:30 p.m. — labels: Cat's Eyes, Sabik, 14, Antares, 13; W·SW, W

August 13–14 • The Moon passes Antares, with Sabik and the Cat's Eyes nearby.

Evening 9 p.m. — labels: Saturn, 20, 21; E·NE, E

August 20–21 • The Moon moves almost vertically, when it passes Saturn (mag. 0.7) in the east ...

Early morning 5 a.m. — labels: Aldebaran, Pleiades, Jupiter, Mars, Elnath, 26, 27, 28; NNE

August 26–28 • The Last Quarter Moon moves along the Pleiades, Aldebaran, Jupiter, Elnath and Mars ...

Morning 6 a.m. — labels: Alhena, Moon, Pollux, Castor; NE

August 30 • Before sunrise, the Moon forms a nice triangle with Pollux and Castor ...

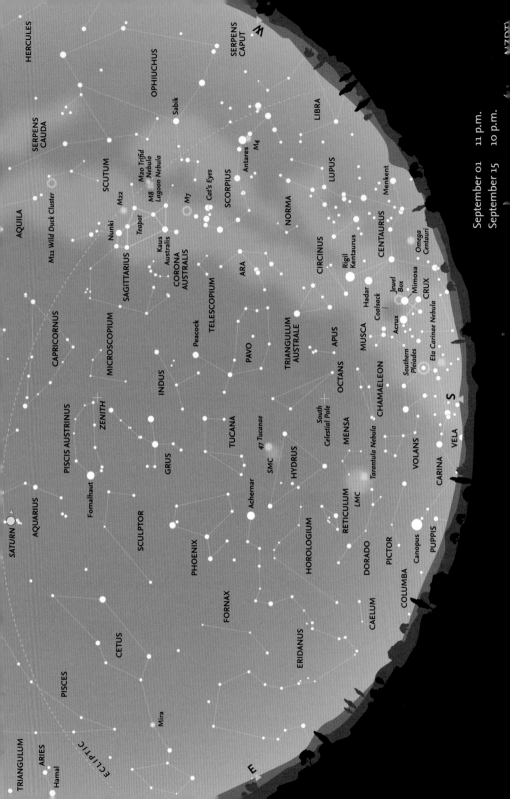

September 01 11 p.m.
September 15 10 p.m.

September – Looking South

The smallest of the constellations, **Crux**, is now very low, but **Canopus** (α Carinae), the second brightest star in the sky, has now become visible once more. **Dorado** and the **Large Magellanic Cloud** (LMC) are higher and easier to see, as are the faint constellations of **Pictor**, **Caelum** and **Reticulum**. The **Small Magellanic Cloud** (SMC) and **47 Tucanae** are now nearly halfway between the horizon and the zenith. Although becoming low, the whole of **Centaurus** and **Lupus** remains visible in the southwest. **Scorpius** with reddish **Antares** is beginning to descend in the west, but **Sagittarius** is clearly seen high in the sky. The constellation of **Piscis Austrinus**, with **Fomalhaut** (α Piscis Austrini), is at the zenith. Below it are the constellations of **Grus** and **Pavo**, with **Achernar** (α Eridani) and almost the whole of the long constellation of **Eridanus**.

Meteors

There are no major meteor showers active in September. A few meteors may be seen from the **α-Aurigid** shower, active from late August, with possible maximum on September 1. The **Southern Taurid** shower begins this month (on September 10) and, although rates are low (less than 6 per hour), often produces very bright fireballs. This is a very long shower, lasting until about November 20. There is one minor shower, the **Piscids**, active throughout September with a slight maximum on September 19, but with an overall rate of no more than 3–5 meteors per hour. However, September is notable for a considerable increase in the number of sporadic meteors, which are, of course, completely unpredictable in location, direction and magnitude.

The 'Teapot' of Sagittarius at the top of the image with the curl of stars forming Corona Australis in the lower left, and the 'Cat's Eyes' (Shaula and Leseth) in the 'sting' of Scorpius near the right edge of the image. The bright open cluster M7 (in Scorpius) is prominent between Sagittarius and the Cat's Eyes (north is up).

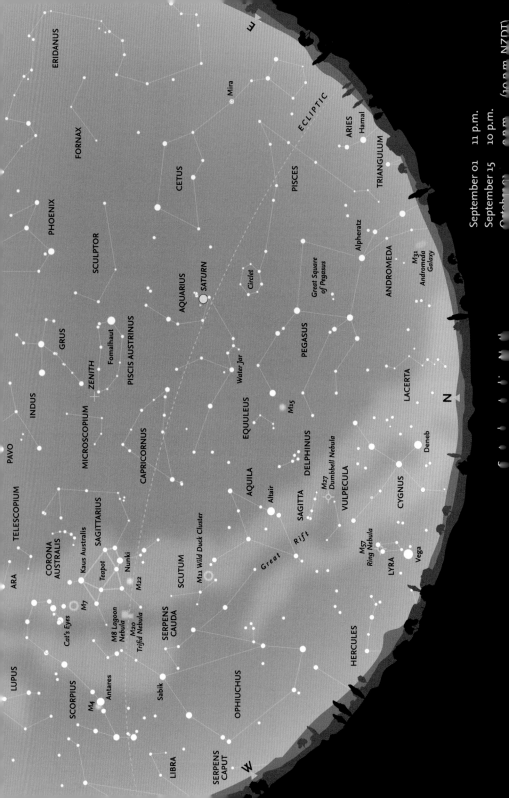

ERIDANUS

FORNAX

PHOENIX

SCULPTOR

GRUS

PISCIS AUSTRINUS

ZENITH

Fomalhaut

INDUS

PAVO

MICROSCOPIUM

CAPRICORNUS

TELESCOPIUM

CORONA
AUSTRALIS

SAGITTARIUS

Kaus Australis

Teapot

Nunki

M22

SCUTUM

M11 Wild Duck Cluster

SERPENS
CAUDA

ARA

M7

Cat's Eyes

M8 Lagoon
Nebula

M20
Trifid Nebula

LUPUS

SCORPIUS

M4

Antares

Sabik

OPHIUCHUS

LIBRA

SERPENS
CAPUT

W

AQUARIUS

SATURN

Mira

ECLIPTIC

CETUS

Circlet

Water Jar

PEGASUS

EQUULEUS

DELPHINUS

AQUILA

Altair

SAGITTA

Great Rift

M27
Dumbbell Nebula

VULPECULA

M57
Ring Nebula

LYRA

Vega

HERCULES

PISCES

Great Square
of Pegasus

Alpheratz

ANDROMEDA

M31
Andromeda
Galaxy

LACERTA

M15

CYGNUS

Deneb

N

ARIES

Hamal

TRIANGULUM

September – Looking North

The Great Square of **Pegasus** is nearing the meridian from the east and, on the west, the three bright stars of the Northern Summer Triangle, **Deneb** (α Cygni), **Altair** (α Aquilae) and **Vega** (α Lyrae) are still clearly seen, although Vega is low on the horizon, as is **M31** in **Andromeda**. **Delphinus** is well-placed, as are the fainter constellation of **Sagitta** and **Scutum** along the Milky Way. Giant **Ophiuchus** is beginning to descend towards the western horizon and much of **Libra** has disappeared. The three zodiacal constellations of **Pisces**, **Aquarius** and **Capricornus** are readily visible. Somewhat higher, **Piscis Austrinus** and **Fomalhaut** (α Piscis Austrini) is at the zenith. **Scorpius** and **Sagittarius** are now on the western side of the sky.

The constellations of Pisces and Aries. The 'Circlet' of Pisces is top left and the three main stars of Aries, bottom right. In 2024, Jupiter is in Aries until the end of April (south is up).

The Moon's phases for September 2024

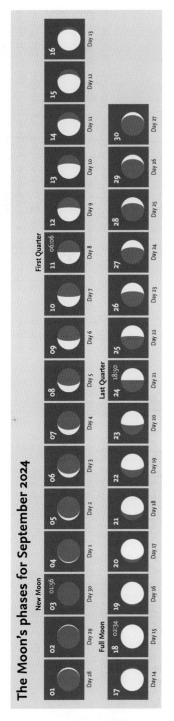

September – Moon and Planets

The Moon

On September 5, the waxing crescent Moon (two days after New) is 1.2°S of **Venus** (mag.-3.8). By September 17, one day before Full, the Moon is 0.3°N of **Saturn**. At Full Moon it is 0.7°N of **Neptune** (mag.7.8) On September 22, it is 4.5°N of **Uranus** (mag.5.6) and the next day, September 23 just before Last Quarter, it is 5.7°N of brilliant **Jupiter** (mag.-2.4). On September 25 it is 4.9°N of **Mars** (mag.0.6).

The Planets

Mercury (mag.0.9 to -1.7) reaches greatest western elongation on September 5. **Venus** (mag.-3,8) moves from **Virgo** into **Libra**, well east of the Sun in the evening sky. **Mars** (mag.0.6) moves from **Taurus** into **Gemini**. **Jupiter** is moving slowly east in **Taurus**. **Saturn** is still retrograding in **Aquarius** and comes to opposition on September 8. **Uranus** (mag.5.6) begins retrograde motion on September 14 in **Aquarius. Neptune** (mag.7.8) is in **Pisces** and is at opposition on September 21 (see the maps on page 25).

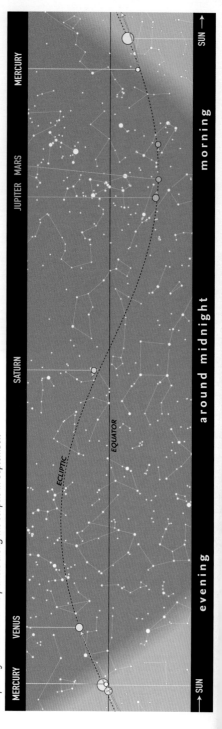

The path of the Sun and the planets along the ecliptic in September.

01		α-Aurigid meteor shower maximum
01	09:16	Mercury (mag. 0.5) 5.0°S of the Moon
03	01:56	New Moon
05	02:30	Mercury at greatest elongation (18.1°W, mag. -0.3)
05	10:16	Venus (mag. -3.8) 1.2°N of the Moon
05	14:54	Moon at apogee = 406,211 km
08	04:35	Saturn at opposition (mag. 0.6)
10–Nov.20		Southern Taurid meteor shower
11	06:06	First Quarter
17	10:22	Saturn (mag. 0.6) 0.3°S of the Moon
18	02:34	Full Moon
18	02:45	Partial lunar eclipse
18	07:35	Neptune (mag. 7.8) 0.7°S of the Moon
18	13:22	Moon at perigee = 357,286 km
21	00:17	Neptune at opposition (mag. 7.8)
22	07:14	Uranus (mag. 5.7) 4.5°S of the Moon
22	12:44	September equinox
23	23:21	Jupiter (mag. -2.4) 5.7°S of the Moon
24	18:50	Last Quarter
25	11:49	Mars (mag. 0.5) 4.9°S of the Moon
29		Daylight Saving Time begins (New Zealand)

Evening 6:30 p.m.

Spica · 6 · Venus · 5 · W

September 5–6 • After sunset, the narrow crescent Moon passes Venus and Spica, in the western sky.

Evening 10 p.m.

Sabik · Antares · Moon · WSW · W

September 10 • The Moon is almost at First Quarter when it meets Antares. Sabik is a little higher and due west.

Morning 5 a.m.

Jupiter · Alhena · Mars · Elnath · Pollux · Castor · 27 · 26 · 25 · 24 · Capella · N · ENE · NE

September 24–27 • The Last Quarter Moon moves along Jupiter, Elnath, Mars, Pollux and Castor. Capella is closer to the horizon and due north.

Evening 7 p.m.

Fomalhaut · Saturn · Moon · 25° · ENE · E

September 17 • High in the east, the Moon and Saturn are close together, with Fomalhaut higher and farther south.

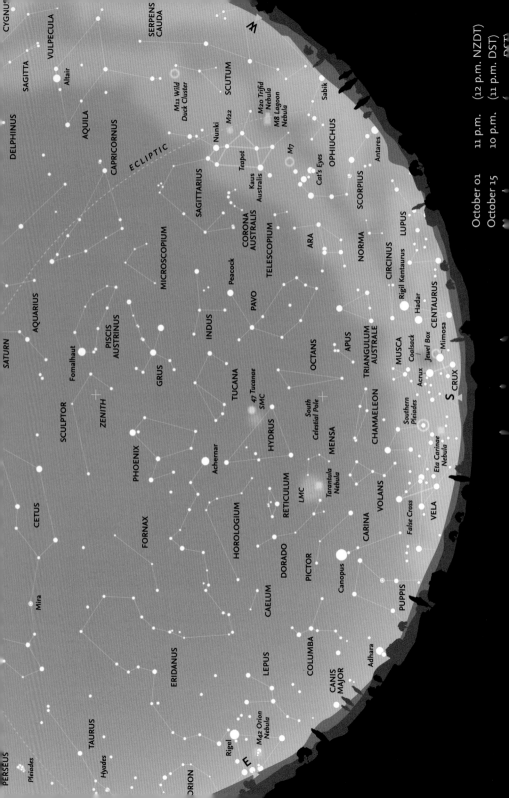

October 01 11 p.m. (12 p.m. NZDT)
October 15 10 p.m. (11 p.m. DST)

October – Looking South

Crux is now extremely low, only just visible above the horizon. The *False Cross* has reappeared, also very low, farther towards the east on the opposite side of the meridian. *Canopus* (α Carinae) is now much higher as is the *Large Magellanic Cloud* (LMC). The *Small Magellanic Cloud* (SMC) and the globular cluster *47 Tucanae* are on the southern meridian, halfway to the zenith as is *Achernar* (α Eridani). (The whole of the long constellation of *Eridanus* is now visible together with *Rigel* in *Orion*.) Still higher are *Phoenix*, *Grus* and *Piscis Austrinus*. *Pavo* has begun to descend in the southwest. *Ophiuchus* has now slipped below the horizon as has much of *Scorpius*, only the 'tail' of which remains visible. *Sagittarius* is getting lower, but remains visible, as do the zodiacal constellations of *Capricornus* and *Aquarius*.

Meteors

The *Orionids* are the major, fairly reliable meteor shower active in October. Like the May *η-Aquariid* shower, the Orionids are associated with Comet 1P/Halley. During this second pass through the stream of particles from the comet, slightly fewer meteors are seen than in May. In both showers the meteors are very fast, and many leave persistent trains. Although the Orionid maximum is nominally October 21–22, in fact there is a very broad maximum, lasting about a week from October 20 to 27, with hourly rates around 20. Occasionally, rates are higher (50–70 per hour). In 2024, the Moon is a waning crescent, so conditions are reasonably favourable.

The faint shower of the *Southern Taurids* (often with bright fireballs) peaks on October 10–11. The Southern Taurid maximum occurs when the Moon is around First Quarter, so conditions are more favourable than those for the Orionids. Towards the end of the month (around October 20), another shower (the *Northern Taurids*) begins to show activity, which peaks early in November. The radiants for both Taurid

showers are close together. The combined position is shown on the 'Looking North' chart. The parent comet for both Taurid showers is Comet 2P/Encke.

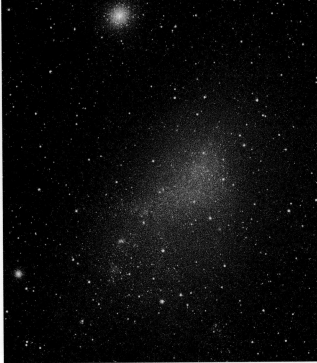

The Small Magellanic Cloud, one of the satellite galaxies of the Milky Way. Near the right edge of this image is 47 Tucanae (NGC 104), which is the second brightest globular cluster in the sky, after Omega Centauri (see page 53). North is up.

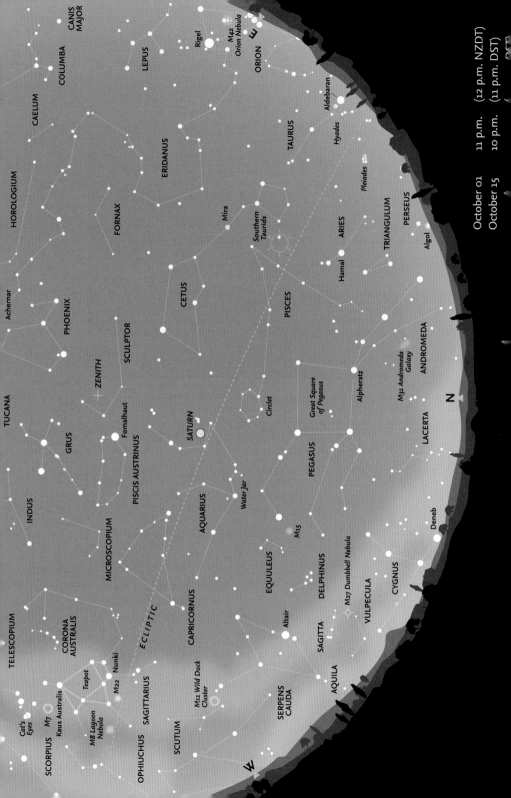

October 01 11 p.m. (12 p.m. NZDT)
October 15 10 p.m. (11 p.m. DST)

October – Looking North

The Great Square of *Pegasus* now dominates the sky to the north and the whole of *Andromeda* with the *Andromeda Galaxy* (M31) is now clear of the horizon. The two chains of stars forming *Pisces* frame the Great Square and, farther along the ecliptic, the constellations of *Aquarius* and *Capricornus* are fully visible. Farther east, all of *Cetus* is visible and, low down on the horizon, *Aldebaran* in *Taurus* is beginning to rise. Due east, *Orion* is becoming visible, with blue-white *Rigel* and the beginning of the long, winding constellation of *Eridanus* that wends its way to *Achernar* (α Eridani), far to the south. West of the meridian, *Lyra*, with *Vega* has disappeared; much of *Cygnus* is invisible and *Deneb* is brushing the horizon. Only *Aquila* and *Altair* (α Aquilae) remain clearly visible. *Vulpecula*, with the planetary nebula *M27* is still visible as is *Sagitta* and, above them, the distinctive constellation of *Delphinus* and the very faint, inconspicuous constellation of *Equuleus.*

The Great Square of Pegasus. The star at the northeastern corner (at the right) is Alpheratz (α Andromedae) and is actually part of the constellation of Andromeda (south is up).

The Moon's phases for October 2024

OCTOBER **91**

October – Moon and Planets

The Moon

On October 2 there is an annular solar eclipse, visible over the Pacific Ocean (see pages 20 and 21). The next day the Moon is 1.8°S of **Mercury** (mag.-1.6). On October 5 the Moon is 3.0°S of **Venus** (mag.-3.9). By October 14 it is 0.1°N of **Saturn** (mag.0.7). On October 15 the Moon is 0.6°N of **Neptune** (mag.7.8) and on October 19 it is 4.5°N of **Uranus** (mag.5.6). On October 23 the Moon is 3.9°N of **Mars** (mag.0.2).

The planets

Mercury (mag.-1.6) moves towards the Sun. **Venus** (mag.-3.9 to -4.0) is moving eastwards in **Virgo**. **Mars** (changing rapidly from mag.0.5 to mag.0.1) is in **Gemini**, moving towards **Cancer**. Jupiter (mag.-2.5 to -2.7) begins retrograde motion on October 9 and is in **Taurus**. **Saturn** (mag.0.7 to 0.8) is still retrograding slowly in **Aquarius**. **Uranus** (mag.5.6) is also retrograding in **Taurus**. **Neptune** (mag.7.8) remains in **Pisces**.

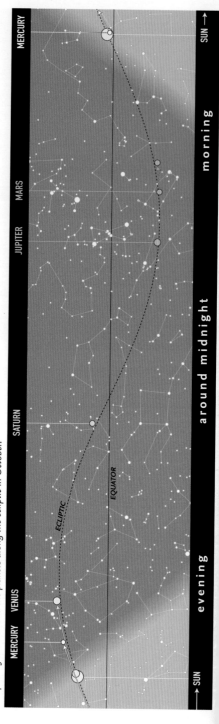

The path of the Sun and the planets along the ecliptic in October.

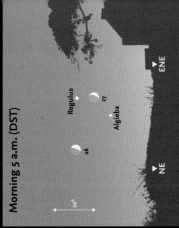

October 22 • The Moon is close to Elnath and Jupiter. Alhena and Betelgeuse are farther east.

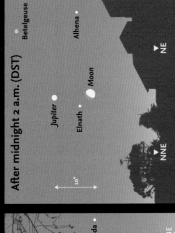

October 14–15 • High in the northeast, the waxing gibbous Moon passes Saturn. Diphda is farther east.

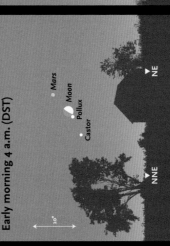

October 26–27 • The waning crescent Moon passes between Regulus and Algieba.

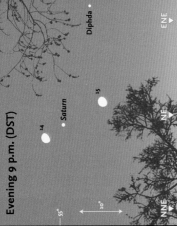

October 24 • The Moon is almost at Last Quarter, when it foms a nice curved line with Castor, Pollux and Mars.

Calendar for October

02	18:46	Annular solar eclipse (Pacific)
02	18:49	New Moon
02	19:39	Moon at apogee = 406,516 km (most distant of the year)
02–Nov.07		Orionid meteor shower
03	00:02	Mercury (mag. -1.6) 1.8°N of the Moon
05	20:26	Venus (mag. -3.9) 3.0°N of the Moon
06		Daylight Saving Time begins (parts of Australia)
06–30		Leonid meteor shower
10–11		Southern Taurid meteor shower maximum
10	18:55	First Quarter
14	18:13	Saturn (mag. 0.7) 0.1°S of the Moon
		An occultation of Saturn is visible from Asia and eastern South Africa
15	17:32	Neptune (mag. 7.8) 0.6°S of the Moon
17	11:26	Full Moon
17	22:50	Moon at perigee = 357,175 km
19	15:52	Uranus (mag. 5.6) 4.5°S of the Moon
20–Dec.10		Northern Taurid meteor shower
21–22		Orionid meteor shower maximum
21	08:04	Jupiter (mag. -2.6) 5.8°S of the Moon
23	19:55	Mars (mag. 0.2) 3.9°S of the Moon
24	08:03	Last Quarter
29	22:50	Moon at apogee = 406,161 km

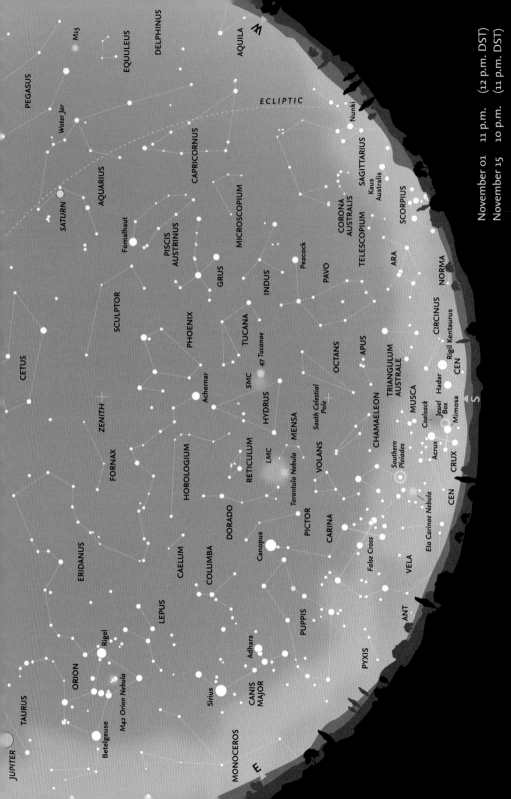

November 01 11 p.m. (12 p.m. DST)
November 15 10 p.m. (11 p.m. DST)

November – Looking South

Crux and the two brightest stars of **Centaurus**, **Rigil Kentaurus** (α Centauri) and **Hadar** (β Centauri), are extremely low on the southern horizon. The **False Cross** on the **Carina/Vela** border is now higher, and the constellation of **Puppis** as well as **Canopus** (α Carinae) and both the **Large Magellanic Cloud** (LMC) and the **Small Magellanic Cloud** (SMC) are clearly visible. **Achernar** (α Eridani) is halfway between the South Celestial Pole and the zenith. The whole of **Eridanus**, which starts near **Rigel** in **Orion**, is now clearly seen as it winds its way to Achernar. **Pavo** is becoming lower in the southwest, and in the west, most of **Sagittarius** is below the horizon, with **Capricornus** descending behind it. **Corona Australis** is still just visible. In the east, **Canis Major** is now clearly seen, together with the small constellations of **Columba** and **Lepus** above it.

Meteors

Two meteor showers begin in September or October but continue into November. The **Orionids** (see page 89), one of the streams associated with Comet 1/P Halley, continue until about November 7. The **Southern Taurids** (see page 83) begin on September 10 and continue until November 20. Because of the location of the radiant, the **Leonid** shower is best seen from the northern hemisphere, but southern observers may see some rising from the horizon. They have a short period of activity (November 6–30), with maximum on November 18. This shower is associated with Comet 55P/Tempel-Tuttle and has shown extraordinary activity on various occasions with many thousands of meteors per hour. The rate in 2024 is likely to be about 10 per hour. These meteors are the fastest shower meteors recorded (about 70 km per second) and often leave persistent trains. The shower is very rich in faint meteors.

There is a minor southern meteor shower that begins activity in late November (nominally November 28). This is the **Phoenicids**, but little

The constellation of Canis Major, with Sirius, the brightest star in the sky (mag. -1.4) in the upper half of the image. Below Sirius is the open cluster M41 (north is up).

is known of the shower, partly because the parent comet is believed to be the disintegrated comet D/1819 W1 (Blanpain). With no accurate knowledge of the location of the remnants of the comet, predicting the possible rate becomes little more than guesswork, but the rate is variable and may rapidly increase (as might be expected) if the orbit is nearby. Bright meteors tend to be quite frequent and the meteors are fairly slow. The radiant is located within **Phoenix**, not far from the border with **Eridanus** and the bright star **Achernar** (α Eridani).

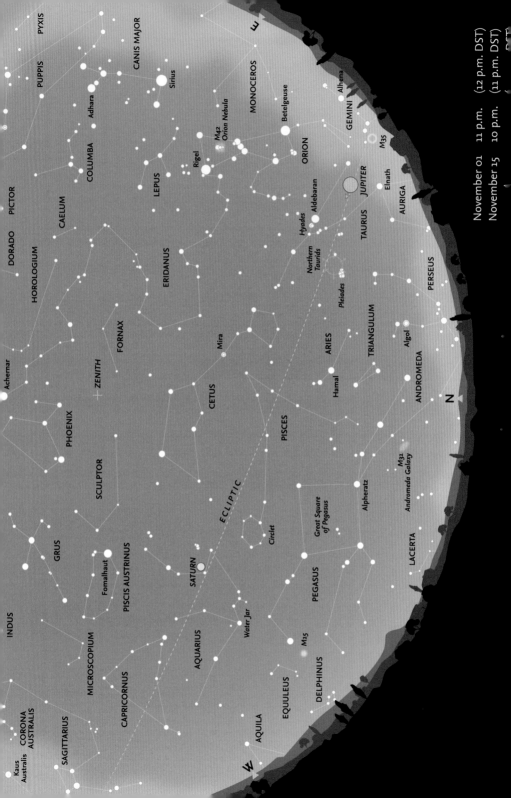

November – Looking North

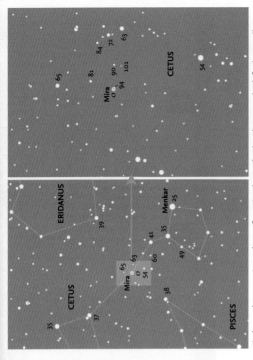

Andromeda is now due north, and the *Andromeda Galaxy* (M31) has risen sufficiently to be clearly seen. The constellation of *Triangulum* lies between Andromeda and the zodiacal constellation of *Aries*. Much of *Perseus* (including the variable star, *Algol*) is now above the horizon, together with part of *Auriga*. The whole of *Pegasus*, with the *Great Square*, is clearly seen and above it the two lines of stars forming *Pisces* and the distinctive asterism of the *Circlet*. Higher still is the constellation of *Cetus* with the famous variable star, *Mira*. The whole of *Taurus* with *Aldebaran* (α Tauri), and the *Pleiades* and the *Hyades* clusters are visible in the southeast. *Orion* has fully risen in the east with *Lepus* above it. The long, winding constellation of *Eridanus* begins near *Rigel* in Orion. The faint constellation of *Monoceros* lies to the east of Orion and straddles the Milky Way. *Canis Major* and brilliant *Sirius* are even farther round towards the east. In the west, the zodiacal constellations of *Aquarius* (with its distinctive asterism of the *Water Jar*) and *Capricornus* are clearly seen, with *Piscis Austrinus* and bright *Fomalhaut* (α Piscis Austrini) higher in the sky. The faint constellation of *Sculptor* lies between Piscis Austrinus and the zenith.

Finder and comparison charts for Mira (o Ceti). The chart on the left shows all stars brighter than magnitude 6.5. The chart on the right shows stars down to magnitude 10.0. The comparison star magnitudes are shown without the decimal point (south is up).

The Moon's phases for November 2024

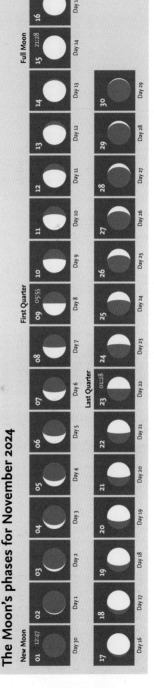

November – Moon and Planets

The Moon

On November 3, the Moon is 2.1°S of **Mercury** (mag. -0.3). On November 4 the Moon is 0.1°S of **Antares** and the next day (at 00:15) is 3.1°S of **Venus** (mag. -4.0). By November 12 the Moon is 0.6°N of **Neptune** (mag. 7.8). On November 16 the Moon is 4.4°N of **Uranus** (mag. 5.6). On November 17 the Moon is 10.3°N of **Aldebaran**, later that day it is 5.5°N of **Jupiter** (mag. -2.8). By November 20, the Moon is 1.9°S of **Pollux**, later that day it is 2.4°N of **Mars** in **Cancer**. By November 22, the Moon passes 2.7°N of **Regulus** between it and **Algieba**. On November 27 the Moon is 0.4°N of **Spica** in **Virgo**.

The Planets

Mercury reaches eastern elongation on November 16. **Venus** is very bright (mag. -4.0 to -4.2) and moving eastwards away from the Sun. **Mars** (mag. 0.1 to -0.7) moves eastwards in **Cancer**. **Jupiter** (mag. -2.7 to -2.8) is retrograding in **Taurus**. **Saturn** (mag. 0.8 to 1.0) is in **Aquarius**. **Uranus** (mag. 5.6) is in **Taurus** and comes to opposition on November 17 (see the maps on page 25). **Neptune** (mag. 7.8) remains in **Pisces**.

The path of the Sun and the planets along the ecliptic in November.

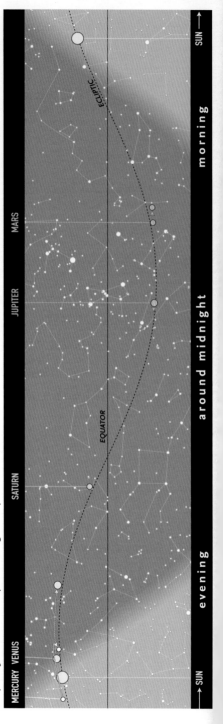

Calendar for November

01	12:47	New Moon
03	07:36	Mercury (mag. -0.3) 2.1°N of the Moon
04	01:06	Antares 0.1°N of the Moon
05	00:15	Venus (mag. -4.0) 3.1°N of the Moon
06–30		Leonid meteor shower
09	05:55	First Quarter
11	01:43	Saturn (mag. 0.9) 0.1°S of the Moon An occultation of Saturn is visible from Central America and northern South America
12–13		Northern Taurid meteor shower maximum
12	02:25	Neptune (mag. 7.8) 0.6°S of the Moon
14	11:16	Moon at perigee = 360,109 km
15	21:28	Full Moon
16	01:13	Uranus (mag. 5.6) 4.4°S of the Moon
16	08:09	Mercury at greatest elongation (22.6°E, mag. -0.3)
17	02:02	Aldebaran 10.3°S of the Moon
17	02:45	Uranus at opposition (mag. 5.6)
17	14:53	Jupiter (mag. -2.8) 5.5°S of the Moon
18		Leonid meteor shower maximum
20	02:44	Pollux 1.9°N of the Moon
20	21:09	Mars (mag. -0.3) 2.4°S of the Moon
22	21:29	Regulus 2.7°S of the Moon
23	01:28	Last Quarter
26	11:56	Moon at apogee = 405,314 km
27	12:16	Spica 0.4°S of the Moon
28–Dec.09		Phoenicid meteor shower

Evening 8 p.m. (DST)

November 3–5 • The Moon passes Mercury, Antares, Sabik, Venus and the Cat's Eyes.

Evening 8 p.m. (DST)

November 10–11 • Very high in the north-northeast, the Moon passes Saturn.

Early morning 4 a.m. (DST)

November 16–17 • The Full Moon passes Uranus (mag. 5.6), the Pleiades and Aldebaran.

Evening 11 p.m. (DST)

November 16–17 • The Moon passes the Pleiades, Aldebaran, Jupiter and Elnath.

After midnight 2 a.m. (DST)

November 20–21 • In the northeast, the Moon passes Pollux, Castor and Mars (mag. 0.3).

Morning 5 a.m. (DST)

November 28 • The Moon is near Spica, due east.

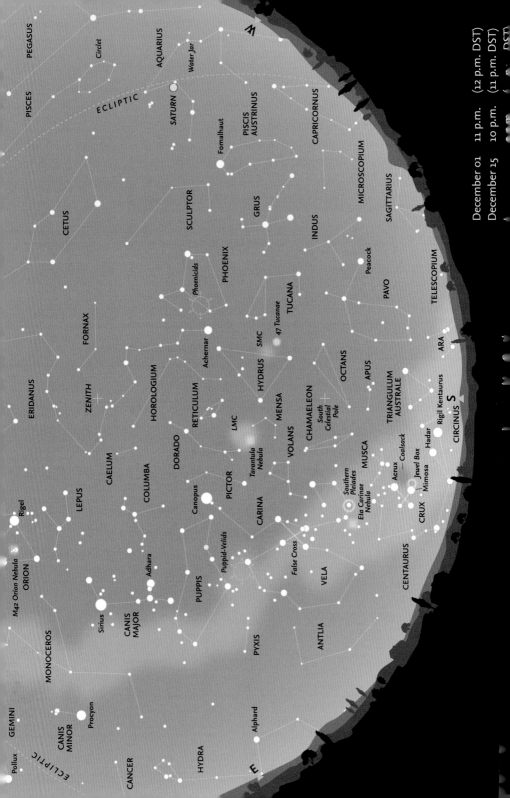

December – Looking South

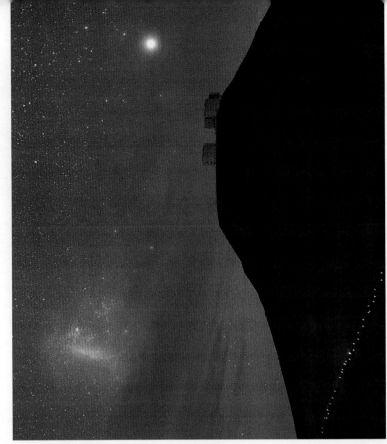

The Large Magellanic Cloud seen over the European Southern Observatory at Paranal in Chile. Brilliant Canopus (α Carinae), the second brightest star in the southern hemisphere, is visible through the low cloud to the right.

Crux and the two brightest stars in **Centaurus**, **Hadar** and **Rigil Kentaurus**, are now higher above the horizon. The **Eta Carina Nebula** and the **Southern Pleiades** are now conveniently placed for observation. Above them, the **False Cross** is clearly seen, with the whole of **Vela** and below it the inconspicuous constellation of **Antlia**. **Carina** with **Canopus** (α Carinae) and **Puppis** are roughly halfway between the horizon and the zenith. **Sirius** and **Canis Major** are high in the east. In the west, **Achernar** (α Eridani) and **Phoenix** are about the same altitude as Canopus. The faint constellations of **Pictor**, **Dorado**, **Reticulum** and **Horlogium** lie between them. **Pavo** with **Peacock** (α Pavonis) is becoming low, as are the constellations of **Indus**, **Grus** and **Piscis Austrinus**. Higher still are the inconspicuous constellations of **Sculptor** and, near the zenith, **Fornax**. **Capricornus** is largely invisible, but most of **Aquarius** may still be seen.

Meteors

The **Phoenicid** shower continues into December, reaching its weak maximum on December 2. The **Puppid Velid** shower's radiant is on the border between the two constellations. The shower begins on December 1, lasting until December 15, with maximum on December 7. It is a weak shower with a maximum hourly rate of about 10 meteors, but bright meteors are often seen. One of the most dependable showers of the year is the **Geminids**, active from December 4 to 20, with maximum in 2024 on December 14–15. The rate is often 60–70 per hour, and may rise even higher.

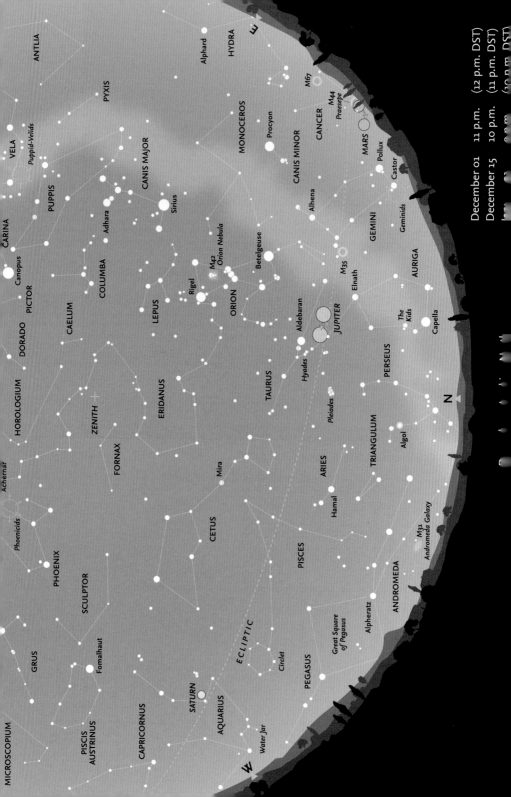

December – Looking North

Most of **Perseus** may be seen due north with, above it, the **Pleiades** cluster. Farther west, **Andromeda** is very low and the southern stars of **Pegasus** have been lost below the horizon. Above Pegasus lies the zodiacal constellation of **Pisces** and, still higher, **Cetus** and the faint constellatons of **Sculptor** and **Fornax**. The famous variable of **Mira** in Cetus (see charts on page 97) is ideally placed for observation. Towards the east, the whole of the constellations of both **Auriga** and **Gemini** is visible, although **Capella** (α Aurigae) and **Castor** and **Pollux** (α and β Gemini) are low on the horizon. **Taurus**, **Orion** and **Canis Minor** are readily visible, together with the faint constellation of **Monoceros**. **Eridanus** wanders from its start near **Rigel** (β Orionis) towards **Achernar** (α Eridani), beyond the zenith.

The constellation of Taurus contains two contrasting open clusters: the compact Pleiades, with its striking blue-white stars, and the more scattered, 'V'-shaped Hyades, which are much closer to us. Orange Aldebaran (α Tauri) is not related to the Hyades, but lies between it and the Earth (south is up).

The Moon's phases for December 2024

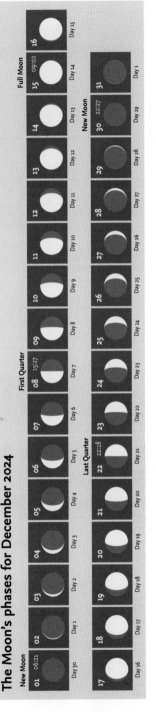

December – Moon and Planets

The Moon

On December 1, the Moon is 0.1°S of *Antares* in *Scorpius*. The next day it is 5.0°S of *Mercury* (too close to the Sun to be visible). By December 4 the Moon is 2.3°S of *Venus* (mag. -4.2) in *Capricornus*. On December 8 it is 0.3°N of *Saturn* in *Aquarius*. The Moon passes 0.8°N of *Neptune* on December 9 and 4.4°N of *Uranus* on December 13. The next day, December 14, the Moon is 10.3°N of *Aldebaran* and later, 5.5°N of *Jupiter* (mag. -2.8). By December 17 the Moon is 2.1°S of *Pollux*. On December 18 the Moon is 0.9°N of *Mars*, which has begun to retrograde in *Cancer*. On December 20, the Moon passes 2.4°N of *Regulus*. On December 24 it is 0.2°N of *Spica* and on December 28 0.1°S of *Antares*. One day before New, the Moon is 6.4°S of *Mercury*.

The planets

Mercury reaches western elongation on December 25 (see the diagram on page 22). *Venus* (mag. -4.2 to -4.5) moves rapidly across Capricornus. *Mars* begins retrograde motion on December 9. *Jupiter* (mag. -2.8) comes to opposition on December 7. *Saturn* (mag. 1.0 to 1.1) is in *Aquarius*. *Uranus* (mag. 5.6) is in *Taurus*, and *Neptune* (mag. 7.9) remains in *Pisces*, where it has been all year.

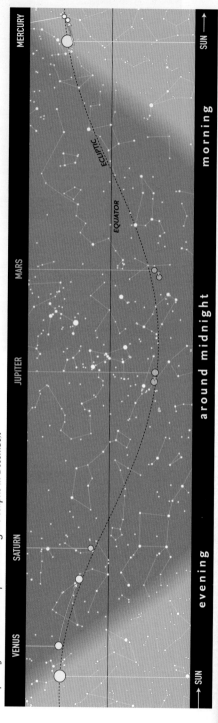

The path of the Sun and the planets along the ecliptic in December.

01–15		Puppid Velid meteor shower
01	06:21	New Moon
01	07:26	Antares 0.1°N of the Moon
02		Phoenicid meteor shower maximum
02	02:09	Mercury (mag.-2.7) 5.0°N of the Moon
04–20		Geminid meteor shower
04	22:40	Venus (mag.-4.2) 2.3°N of the Moon
07		Puppid Velid meteor shower maximum
07	20:58	Jupiter at opposition (mag.-2.8)
08	09:19	Saturn (mag.1.0) 0.3°S of the Moon
08	15:27	First Quarter
09	09:19	Neptune (mag.7.9) 0.8°S of the Moon
12	13:20	Moon at perigee = 365,361 km
13	09:34	Uranus (mag.5.6) 4.4°S of the Moon
14–15		Geminid meteor shower maximum
14	05:31	Minor planet (15) Eunomia at opposition (mag. 8.0)
14	12:30	Aldebaran 10.3°S of the Moon
14	19:32	Jupiter (mag.-2.8) 5.5°S of the Moon
15	09:02	Full Moon
17	12:49	Pollux 2.1°N of the Moon
18	08:49	Mars (mag.-0.9) 0.9°S of the Moon
20	06:18	Regulus 2.4°S of the Moon
21	09:21	Southern summer solstice
22	22:18	Last Quarter
24	07:25	Moon at apogee = 404,485 km
24	20:11	Spica 0.2°S of the Moon
25	02:30	Mercury at greatest elongation (22.0°W, mag.-0.4)
28	15:17	Antares 0.1°N of the Moon
29	04:21	Mercury (mag.-0.4) 6.4°N of the Moon
30	22:27	New Moon

Evening 9 p.m. (DST)

December 4–5 • The waxing crescent Moon passes Nunki and Venus, in the western sky.

Evening 9 p.m. (DST)

December 8 • High in the northwest, the Moon is close to Saturn.

Evening 10 p.m. (DST)

December 13–15 • The nearly Full Moon passes along the Pleiades, Aldebaran, Jupiter and Elnath.

Midnight (DST)

December 17/18–18/19 • Low in the northeast, the Moon moves from Pollux to Mars. Alhena and Procyon are about twenty degrees higher.

After midnight 2 a.m. (DST)

December 20–21 • The waning gibbous Moon passes between Regulus and Algieba. Denebola (β Leo) is very close to the horizon and not easy to detect.

Dark Sky Sites

International Dark-Sky Association Sites

The *International Dark-Sky Association* (IDA) recognizes various categories of sites that offer areas where the sky is dark at night, free from light pollution and particularly suitable for astronomical observing. Although a number of sites are under consideration, the majority of confirmed sites are in North America. There are more than 90 in the United States and Canada. There are 20 sites in Great Britain and Ireland, seven in Europe, and one each in Israel, Japan and South Korea. There are just 13 sites in the southern hemisphere.

Details of IDA are at: https://www.darksky.org/. Information on the various categories and individual sites are at:
https://www.darksky.org/our-work/conservation/idsp/.

Many of these sites have major observatories or other facilities available for public observing (often at specific dates or times).

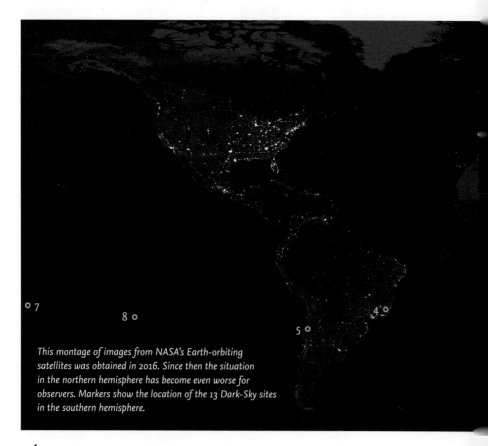

This montage of images from NASA's Earth-orbiting satellites was obtained in 2016. Since then the situation in the northern hemisphere has become even worse for observers. Markers show the location of the 13 Dark-Sky sites in the southern hemisphere.

1 *!Ae!Hai Kalahari Heritage Park* (South Africa)
2 *Aoraki Mackenzie* (New Zealand)
3 *Aotea / Great Barrier Island* (New Zealand)
4 *Desengano State Park* (Brazil)
5 *Gabriela Mistral* (Chile)
6 *NamibRand Nature Reserve* (Namibia)
7 *Niue* (New Zealand)
8 *Pitcairn Islands* (UK)
9 *River Murray* (Australia)
10 *Stewart Island / Rakiura* (New Zealand)
11 *The Jump-Up* (Australia)
12 *Wai-Iti* (New Zealand)
13 *Warrumbungle National Park* (Australia)

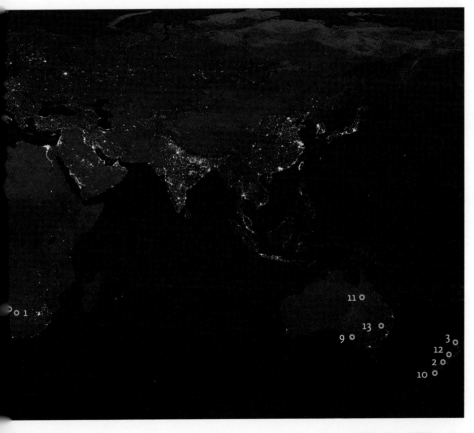

Glossary and Tables

aphelion The point on an orbit that is farthest from the Sun.

apogee The point on its orbit at which the Moon is farthest from the Earth.

appulse The apparently close approach of two celestial objects; two planets, or a planet and star.

astronomical unit (AU) The mean distance of the Earth from the Sun, 149,597,870 km.

celestial equator The great circle on the celestial sphere that is in the same plane as the Earth's equator.

celestial sphere The apparent sphere surrounding the Earth on which all celestial bodies (stars, planets, etc.) seem to be located.

conjunction The point in time when two celestial objects have the same celestial longitude. In the case of the Sun and a planet, superior conjunction occurs when the planet lies on the far side of the Sun (as seen from Earth). For Mercury and Venus, inferior conjunction occurs when they pass between the Sun and the Earth.

direct motion Motion from west to east on the sky.

ecliptic The apparent path of the Sun across the sky throughout the year. Also: the plane of the Earth's orbit in space.

elongation The point at which an inferior planet has the greatest angular distance from the Sun, as seen from Earth.

equinox The two points during the year when night and day have equal duration. Also: the points on the sky at which the ecliptic intersects the celestial equator. The vernal (spring) equinox is of particular importance in astronomy.

gibbous The stage in the sequence of phases at which the illumination of a body lies between half and full. In the case of the Moon, the term is applied to phases between First Quarter and Full, and between Full and Last Quarter.

inferior planet Either of the planets Mercury or Venus, which have orbits inside that of the Earth.

magnitude The brightness of a star, planet or other celestial body. It is a logarithmic scale, where larger numbers indicate fainter brightness. A difference of 5 in magnitude indicates a difference of 100 in actual brightness, thus a first-magnitude star is 100 times as bright as one of sixth magnitude.

meridian The great circle passing through the North and South Poles of a body and the observer's position; or the corresponding great circle on the celestial sphere that passes through the North and South Celestial Poles and also through the observer's zenith.

nadir The point on the celestial sphere directly beneath the observer's feet, opposite the zenith.

occultation The disappearance of one celestial body behind another, such as when stars or planets are hidden behind the Moon.

opposition The point on a superior planet's orbit at which it is directly opposite the Sun in the sky.

perigee The point on its orbit at which the Moon is closest to the Earth.

perihelion The point on an orbit that is closest to the Sun.

retrograde motion Motion from east to west on the sky.

superior planet A planet that has an orbit outside that of the Earth.

vernal equinox The point at which the Sun, in its apparent motion along the ecliptic, crosses the celestial equator from south to north. Also known as the First Point of Aries.

zenith The point directly above the observer's head.

zodiac A band, streching 8° on either side of the ecliptic, within which the Moon and planets appear to move. It consists of twelve equal areas, originally named after the constellation that once lay within it.

The Constellations

There are 88 constellations covering the whole of the celestial sphere, but 4 of these in the northern hemisphere (Camelopardalis, Cassiopeia, Cepheus and Ursa Minor) can never be seen (even in part) from a latitude of 35°S, so are omitted from this table. The names themselves are expressed in Latin, and the names of stars are frequently given by Greek letters (see next page) followed by the genitive of the constellation name. The genitives and English names of the various constellations are included.

Name	Genitive	Abbr.	English name
Andromeda	Andromedae	And	Andromeda
Antlia	Antliae	Ant	Air Pump
Apus	Apodis	Aps	Bird of Paradise
Aquarius	Aquarii	Aqr	Water Bearer
Aquila	Aquilae	Aql	Eagle
Ara	Arae	Ara	Altar
Aries	Arietis	Ari	Ram
Auriga	Aurigae	Aur	Charioteer
Boötes	Boötis	Boo	Herdsman
Caelum	Caeli	Cae	Burin
Cancer	Cancri	Cnc	Crab
Canes Venatici	Canum Venaticorum	CVn	Hunting Dogs
Canis Major	Canis Majoris	CMa	Big Dog
Canis Minor	Canis Minoris	CMi	Little Dog
Capricornus	Capricorni	Cap	Sea Goat
Carina	Carinae	Car	Keel
Centaurus	Centauri	Cen	Centaur
Cetus	Ceti	Cet	Whale
Chamaeleon	Chamaeleontis	Cha	Chameleon
Circinus	Circini	Cir	Compasses
Columba	Columbae	Col	Dove
Coma Berenices	Comae Berenices	Com	Berenice's Hair
Corona Australis	Coronae Australis	CrA	Southern Crown
Corona Borealis	Coronae Borealis	CrB	Northern Crown
Corvus	Corvi	Crv	Crow
Crater	Crateris	Crt	Cup
Crux	Crucis	Cru	Southern Cross
Cygnus	Cygni	Cyg	Swan
Delphinus	Delphini	Del	Dolphin
Dorado	Doradus	Dor	Dorado
Draco	Draconis	Dra	Dragon
Equuleus	Equulei	Equ	Little Horse
Eridanus	Eridani	Eri	River Eridanus
Fornax	Fornacis	For	Furnace
Gemini	Geminorum	Gem	Twins
Grus	Gruis	Gru	Crane
Hercules	Herculis	Her	Hercules
Horologium	Horologii	Hor	Clock
Hydra	Hydrae	Hya	Water Snake
Hydrus	Hydri	Hyi	Lesser Water Snake
Indus	Indi	Ind	Indian
Lacerta	Lacertae	Lac	Lizard

Name	Genitive	Abbr.	English name
Leo	Leonis	Leo	Lion
Leo Minor	Leonis Minoris	LMi	Little Lion
Lepus	Leporis	Lep	Hare
Libra	Librae	Lib	Scales
Lupus	Lupi	Lup	Wolf
Lynx	Lyncis	Lyn	Lynx
Lyra	Lyrae	Lyr	Lyre
Mensa	Mensae	Men	Table Mountain
Microscopium	Microscopii	Mic	Microscope
Monoceros	Monocerotis	Mon	Unicorn
Musca	Muscae	Mus	Fly
Norma	Normae	Nor	Set Square
Octans	Octantis	Oct	Octant
Ophiuchus	Ophiuchi	Oph	Serpent Bearer
Orion	Orionis	Ori	Orion
Pavo	Pavonis	Pav	Peacock
Pegasus	Pegasi	Peg	Pegasus
Perseus	Persei	Per	Perseus
Phoenix	Phoenicis	Phe	Phoenix
Pictor	Pictoris	Pic	Painter's Easel
Pisces	Piscium	Psc	Fishes
Piscis Austrinus	Piscis Austrini	PsA	Southern Fish
Puppis	Puppis	Pup	Stern
Pyxis	Pyxidis	Pyx	Compass
Reticulum	Reticuli	Ret	Net
Sagitta	Sagittae	Sge	Arrow
Sagittarius	Sagittarii	Sgr	Archer
Scorpius	Scorpii	Sco	Scorpion
Sculptor	Sulptoris	Scu	Sculptor
Scutum	Scuti	Sct	Shield
Serpens	Serpentis	Ser	Serpent
Sextans	Sextantis	Sex	Sextant
Taurus	Tauri	Tau	Bull
Telescopium	Telescopii	Tel	Telescope
Triangulum	Trianguli	Tri	Triangle
Triangulum Australe	Trianguli Australis	TrA	Southern Triangle
Tucana	Tucanae	Tuc	Toucan
Ursa Major	Ursae Majoris	UMa	Great Bear
Vela	Velorum	Vel	Sails
Virgo	Virginis	Vir	Virgin
Volans	Volantis	Vol	Flying Fish
Vulpecula	Vulpeculae	Vul	Fox

The Greek Alphabet

α	Alpha	ε	Epsilon	ι	Iota	ν	Nu	ρ	Rho	φ (φ)	Phi
β	Beta	ζ	Zeta	κ	Kappa	ξ	Xi	σ (ς)	Sigma	χ	Chi
γ	Gamma	η	Eta	λ	Lambda	o	Omicron	τ	Tau	ψ	Psi
δ	Delta	θ (ϑ)	Theta	μ	Mu	π	Pi	υ	Upsilon	ω	Omega

Some common asterisms

Belt of Orion	δ, ε and ζ Orionis
Cat's Eyes	λ and υ Scorpii
Circlet	γ, θ, ι, λ and κ Piscium
False Cross	ε and ι Carinae and δ and κ Velorum
Fish Hook	α, β, δ and π Scorpii
Head of Cetus	α, γ, ξ², μ and λ Ceti
Head of Hydra	δ, ε, ζ, η, ρ and σ Hydrae
Job's Coffin	α, β, γ and δ Delphini
Keystone	ε, ζ, η and π Herculis
Kids	ζ and η Aurigae
Milk Dipper	ζ, γ, σ, φ and λ Sagittarii
Pot	= Saucepan
Saucepan	ι, θ, ζ, ε, δ and η Orionis
Sickle	α, η, γ, ζ, μ and ε Leonis
Southern Pointers	α and β Centauri
Square of Pegasus	α, β and γ Pegasi with α Andromedae
Sword of Orion	θ and ι Orionis
Teapot	γ, ε, δ, λ, φ, σ, τ and ζ Sagittarii
Water Jar	γ, η, κ and ζ Aquarii
Y of Aquarius	= Water Jar

Acknowledgements

Denis Buczynski, Portmahomack, Ross-shire – p.32 (Fireball)

Dave Chapman, Dartmouth, Nova Scotia, Canada – p.77 (LMC)

European Southern Observatory – pp.53, 89, 101 (Magellanic Clouds)

Akira Fuji – p.21 (Lunar eclipse)

Bernhard Hubl – pp.35, 43, 47, 49, 59, 65, 73, 83, 85, 91, 95, 103 (Constellation photographs)

Nick James – p.29 (Comet NEOWISE)

Arthur Page, Queensland, Australia – pp.41, 71 (Constellation photographs)

Damian Peach, Hamble, UK – p.23 (Mars photo)

peresanz/Shutterstock – p.37 (Orion)

For the 2024 Guide, the editorial support was provided by Jessica Lee, Astronomy Education Officer, and Patricia Skelton, Senior Astronomy Manager: Education & Outreach.

Further Information

Books

Bone, Neil (1993), *Observer's Handbook: Meteors*, George Philip, London & Sky Publ. Corp., Cambridge, Mass.

Cook, J., ed. (1999), *The Hatfield Photographic Lunar Atlas*, Springer-Verlag, New York

Dunlop, Storm (1999), *Wild Guide to the Night Sky*, HarperCollins, London

Dunlop, Storm (2012), *Practical Astronomy*, 3rd edn, Philip's, London

Dunlop, Storm, Rükl, Antonin & Tirion, Wil (2005), *Collins Atlas of the Night Sky*, HarperCollins, London

Ellyard, David & Tirion, Wil (2008), *Southern Sky Guide*, 3rd edn, Cambridge University Press, Cambridge

Heifetz, Milton & Tirion, Wil (2017), *A Walk through the Heavens*, 4th edn, Cambridge University Press, Cambridge

Heifetz, Milton & Tirion, Wil (2012), *A Walk through the Southern Sky*, 3rd edn, Cambridge University Press, Cambridge

O'Meara, Stephen J. (2008), *Observing the Night Sky with Binoculars*, Cambridge University Press, Cambridge

Ridpath, Ian (2018), *Star Tales*, 2nd edn, Lutterworth Press, Cambridge, UK

Ridpath, Ian, ed. (2003), *Oxford Dictionary of Astronomy*, 2nd edn, Oxford University Press, Oxford

Ridpath, Ian, ed. (2004), *Norton's Star Atlas*, 20th edn, Pi Press, New York

Ridpath, Ian & Tirion, Wil (2004), *Collins Gem – Stars*, HarperCollins, London

Ridpath, Ian & Tirion, Wil (2017), *Collins Pocket Guide Stars and Planets*, 5th edn, HarperCollins, London

Ridpath, Ian & Tirion, Wil (2019), *The Monthly Sky Guide*, 10th edn, Dover Publications, New York

Rükl, Antonín (1990), *Hamlyn Atlas of the Moon*, Hamlyn, London & Astro Media Inc., Milwaukee

Rükl, Antonín (2004), *Atlas of the Moon*, Sky Publishing Corp., Cambridge, Mass.

Scagell, Robin (2000), *Philip's Stargazing with a Telescope*, George Philip, London

Sky & Telescope (2017), *Astronomy 2018*, Australian Sky & Telescope, Quasar Publishing, Georges Hall, NSW

Stimac, Valerie (2019) *Dark Skies: A Practical Guide to Astrotourism*, Lonely Planet, Franklin, TN

Tirion, Wil (2011), *Cambridge Star Atlas*, 4th edn, Cambridge University Press, Cambridge

Tirion, Wil & Sinnott, Roger (1999), *Sky Atlas 2000.0*, 2nd edn, Sky Publishing Corp., Cambridge, Mass. & Cambridge University Press, Cambridge

Journals

Astronomy, Astro Media Corp., 21027 Crossroads Circle, P.O. Box 1612, Waukesha, WI 53187-1612 USA. http://www.astronomy.com

Astronomy Now, Pole Star Publications, PO Box 175, Tonbridge, Kent TN10 4QX UK. http://astronomynow.com

Sky at Night Magazine, BBC publications, London. http://skyatnightmagazine.com

Sky & Telescope, Sky Publishing Corp., Cambridge, MA 02138-1200 USA. http://www.skyandtelescope.com/

Societies

British Astronomical Association, Burlington House, Piccadilly, London W1J 0DU. http://www.britastro.org/
The principal British organization for amateur astronomers (with some professional members), particularly for those interested in carrying out observational programmes. Its membership is, however, worldwide. It publishes fully refereed, scientific papers and other material in its well-regarded journal.

Federation of Astronomical Societies, Secretary: Ken Sheldon, Whitehaven, Maytree Road, Lower Moor, Pershore, Worcs. WR10 2NY. http://www.fedastro.org.uk/fas/
An organization that is able to provide contact information for local astronomical societies in the United Kingdom.

Royal Astronomical Society, Burlington House, Piccadilly, London W1J 0BQ. http://www.ras.org.uk/
The premier astronomical society, with membership primarily drawn from professionals and experienced amateurs. It has an exceptional library and is a designated centre for the retention of certain classes of astronomical data. Its publications are the standard medium for dissemination of astronomical research.

Society for Popular Astronomy, 36 Fairway, Keyworth, Nottingham NG12 5DU.
http://www.popastro.com/
A society for astronomical beginners of all ages, which concentrates on increasing members' understanding and enjoyment, but which does have some observational programmes. Its journal is entitled *Popular Astronomy*.

Software

Planetary, Stellar and Lunar Visibility (planetary and eclipse freeware): Alcyone Software, Germany.
http://www.alcyone.de
Redshift, Redshift-Live. http://www.redshift-live.com/en/
Starry Night & Starry Night Pro, Sienna Software Inc., Toronto, Canada. http://www.starrynight.com

Internet sources

There are numerous sites with information about all aspects of astronomy, and all of those have numerous links. Although many amateur sites are excellent, treat any statements and data with caution. The sites listed below offer accurate information. Please note that the URLs may change. If so, use a good search engine, such as Google, to locate the information source.

Information

Astronomical data (inc. eclipses) HM Nautical Almanac Office: http://astro.ukho.gov.uk
Auroral information Michigan Tech: http://www.geo.mtu.edu/weather/aurora/
Comets JPL Solar System Dynamics: http://ssd.jpl.nasa.gov/
American Meteor Society: http://amsmeteors.org/
Deep-sky objects Saguaro Astronomy Club Database: http://www.virtualcolony.com/sac/
Eclipses NASA Eclipse Page: http://eclipse.gsfc.nasa.gov/eclipse.html
Ice in Space (Southern Hemisphere Online Astronomy Forum): http://www.iceinspace.com.au/index.php?home
Moon (inc. Atlas) Inconstant Moon: http://www.inconstantmoon.com/
Planets Planetary Fact Sheets: http://nssdc.gsfc.nasa.gov/planetary/planetfact.html
Satellites (inc. International Space Station)
 Heavens Above: http://www.heavens-above.com/
 Visual Satellite Observer: http://www.satobs.org/
Star Chart http://www.skyandtelescope.com/observing/interactive-sky-watching-tools/interactive-sky-chart/
What's Visible
 Skyhound: http://www.skyhound.com/sh/skyhound.html
 Skyview Cafe: http://www.skyviewcafe.com

Institutes and Organizations

European Space Agency: http://www.esa.int/
International Dark-Sky Association: http://www.darksky.org/
International Meteor Organization https://www.imo.net/
RASC Dark Sky: https://rasc.ca/dark-sky-sites/
Jet Propulsion Laboratory: http://www.jpl.nasa.gov/
Lunar and Planetary Institute: http://www.lpi.usra.edu/
National Aeronautics and Space Administration: http://www.hq.nasa.gov/
Solar Data Analysis Center: http://umbra.gsfc.nasa.gov/
Space Telescope Science Institute: http://www.stsci.edu/